Historic England

Cheltenham

David Elder

AMBERLEY

For Syd and Margaret

First published 2018

Amberley Publishing
The Hill, Stroud, Gloucestershire, GL5 4EP
www.amberley-books.com

Copyright © David Elder, 2018

The right of David Elder to be identified as the Author
of this work has been asserted in accordance with the
Copyright, Designs and Patents Act 1988.

ISBN 978 1 4456 8366 9 (print)
ISBN 978 1 4456 8367 6 (ebook)

British Library Cataloguing in Publication Data.
A catalogue record for this book is available from the
British Library.

Origination by Amberley Publishing.
Printed in Great Britain.

Contents

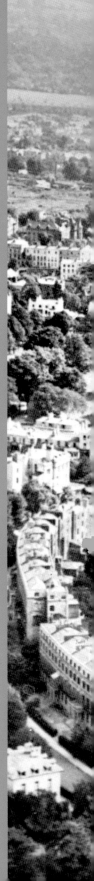

Introduction 5

Before the Spa 6

Regency and Beyond 11

Places of Worship 32

Public Buildings 39

Education 58

Entertainment and Leisure 64

The Races 73

Industry and Commerce 79

Acknowledgements 95

About the Author 95

About the Archive 96

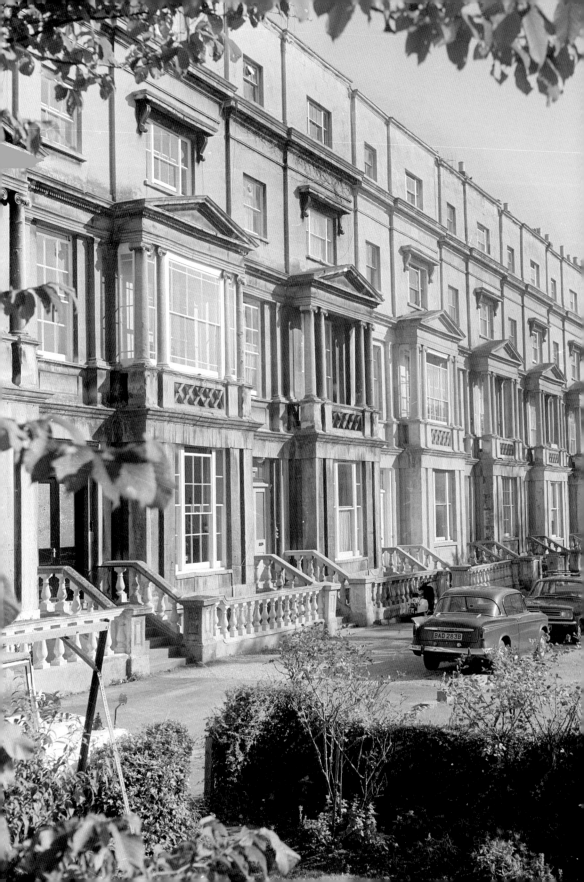

Introduction

Although Cheltenham is often recognised as England's most complete Regency town, its history dates back much further than the beginning of the nineteenth century. Traces of its Iron Age settlements are still visible on Cleeve Hill to the north-east and Leckhampton Hill to the south. Moreover, a Neolithic long barrow (4,000–2,000 BC) was reputedly excavated in the town in 1832. However, the first recorded mention of Cheltenham was in AD 773 when it was known as *Celtan hom*, possibly deriving from 'well-watered valley [hamm] of (the hill called) *Cilta* or *Celta*'. Tangible reminders of its medieval past are still present in St Mary's Church (recently renamed Cheltenham Minster) and buildings such as Leckhampton Court. By the sixteenth century Cheltenham had developed along one long street (now the High Street), the antiquarian John Leland referring to it as Cheltenham Street and describing it as 'a longe toune havynge a market'.

From 1716 Cheltenham gradually developed as a spa resort after mineral waters were discovered on farmland, reputedly from pigeons pecking at the calcareous particles for the digestion of their food. In the late 1720s Daniel Defoe predicted that 'the mineral waters lately discovered at Cheltenham … are what will make this place more and more remarkable, and frequented'. Thereafter, the spa's popularity was boosted by a range of improvements by Captain Henry Skillicorne from 1738 onwards. However, the major turning point in the town's fortunes only came in 1788 following a five-week visit by King George III, after which, to quote the diarist and novelist Fanny Burney, he 'declared the Cheltenham waters were admirable friends to the constitution, by bringing disorders out of the habit'. The town's popularity continued to gain momentum after 1800, its population increasing fourfold between 1801 and 1821, and by the middle of the nineteenth century its importance can be gauged from the fact that, in 1854, it could boast the installation of pillar letter boxes eight months before London.

Although the fashion for water-drinking declined steadily from the 1830s onwards, by the 1850s a gradual shift was taking place. Pleasure-seeking at the spa gave way to evangelical preaching and learning as Cheltenham started to reinvent itself as an important centre for religion and education. Today, the town's wealth of churches and chapels, as well as top-ranking educational institutions, bear witness to this. Later, the town also developed as a centre for sport, particularly horse racing and cricket, its first Gold Cup race taking place as far back as 1815 and the first cricket festival, held at Cheltenham College, in 1872. Finally, from the first half of the nineteenth century, when it developed its reputation as a first-class shopping centre, to the present day, where at Government Communications Headquarters (GCHQ) some of the world's greatest problem-solving and analytical minds are located, Cheltenham has also continued to find prosperity through a plethora of different trades and industries.

Before the Spa

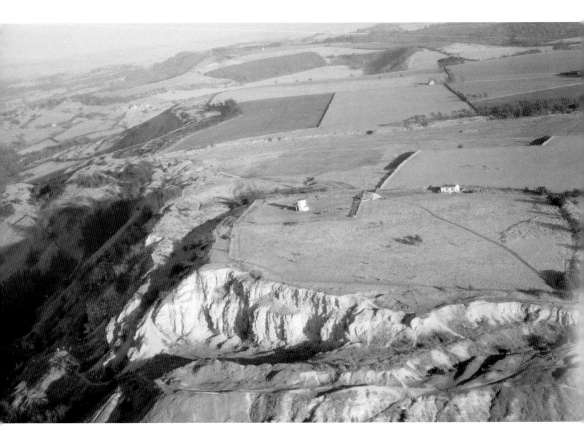

Above: Leckhampton Camp
With natural lines of defence along the western and northern edges, the Iron Age hill fort, believed to date from *c*. 800 BC to AD 43, was further fortified by single ramparts on its southern and eastern slopes. The site also contains a rare round barrow, which is most unusual because it is contained within a square enclosure. (© Historic England Archive. Harold Wingham Collection)

Opposite above: Cleeve Hill Camp
At 310 metres, Cleeve Hill is the highest point in the Cotswolds. Occupied today by common ground and a golf course, the area also contains a 3-acre Iron Age hill fort and an earthwork enclosure known as The Ring. The fort relied on double defensive moats on the western face of the Cotswold escarpment for protection. (© Historic England Archive. Harold Wingham Collection)

*Opposite belo*w: Battledown Camp
It is thought that 'Battledown' originated from an Old English name meaning 'Baedala's farm'. Baedala was a Saxon who, it is surmised, built an enclosure *c*. AD 500 on what was then a densely wooded hill. Battledown Camp was also a possible Iron Age hill fort, although another theory suggests it could simply be a natural cluster of gullies and scarps. (© Historic England Archive. Harold Wingham Collection)

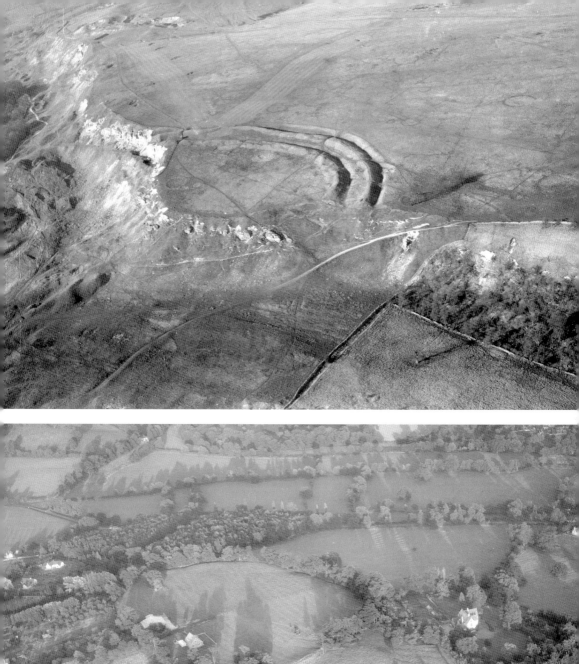
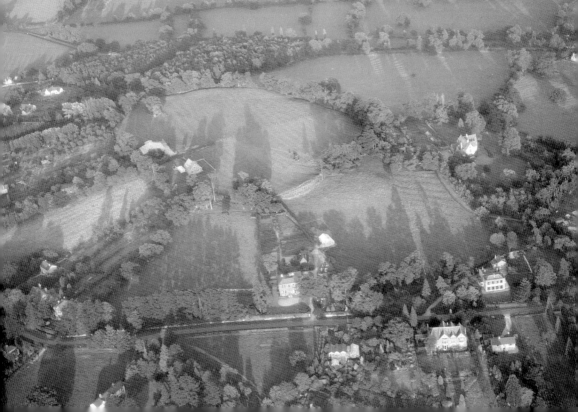

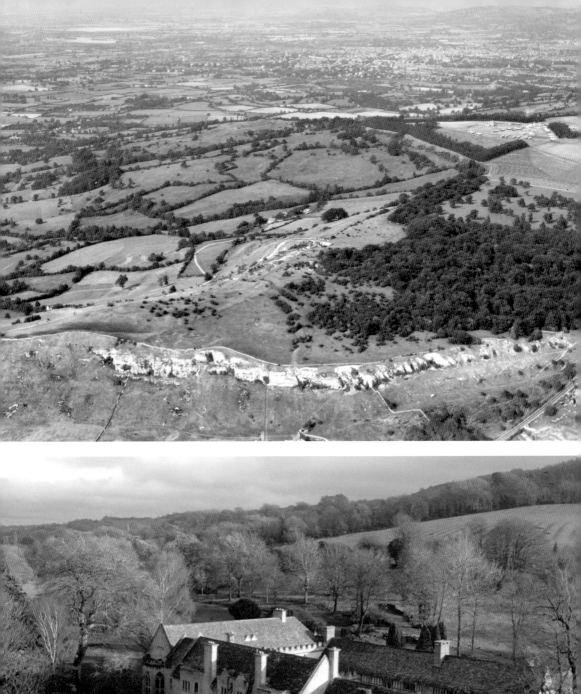
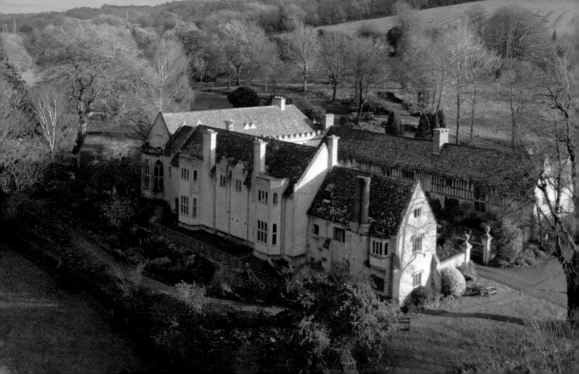

Above: Arle Court House
Located on Kingsmead Road on the site of an Elizabethan manor house called Arle Court, the house provides a tangible link to Cheltenham's fifteenth-century past. Although the original Arle Court was demolished *c.* 1880, some of its internal fittings were transferred to a new house, now named Manor by the Lake (see p. 83), and part of the building incorporated into Arle Court House.

Opposite above: Crickley Hill
A Neolithic settlement was excavated here between 1969 and 1993. Ideally situated for defence on the edge of the Cotswold escarpment, the hill fort was the site of the earliest authenticated battlefield in Britain, during the sixth century BC. One interesting feature that survived the hill fort's sacking was a circular monument, which was probably used for sacred or ceremonial purposes. (© Historic England Archive. Aerofilms Collection)

Opposite below: Leckhampton Court
Today a Sue Ryder Care hospice providing residential and day-care support for cancer patients, Leckhampton Court is the oldest surviving medieval house in Cheltenham. While part of the current building dates from around 1330, the history of the settlement extends back even further, to Saxon times, when Leckhampton formed part of the royal manor of Cheltenham.

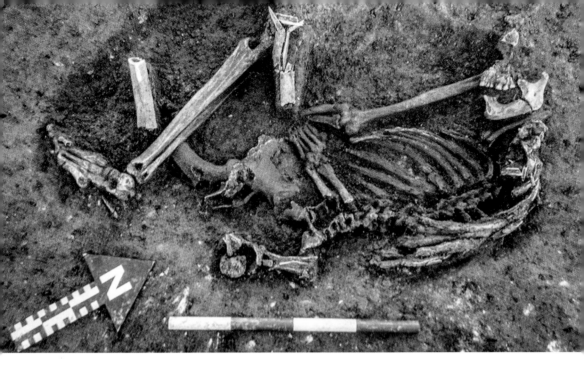

Above: Recent Archaeological Excavations
In 2010 an excavation at All Saints' Academy (formerly Kingsmead School) revealed two Iron Age burials and the remains of a small Anglo-Saxon settlement. This included a post-built building thought to be a farmstead dating from *c*. AD 550–700. It is considered that this predated an Anglo-Saxon settlement (AD 716–757) at nearby Arle.

Below: Charlton Kings
Although now part of Cheltenham borough, Charlton Kings retains a distinct village identity. In 1980 evidence of a Middle Iron Age early settlement was discovered at Vineyard Farm beneath a Roman villa. This print by Henry Lamb *c*. 1825 was produced approximately 650 years after its name 'Cherlton' (meaning 'the peasants' farmstead') was first noted.

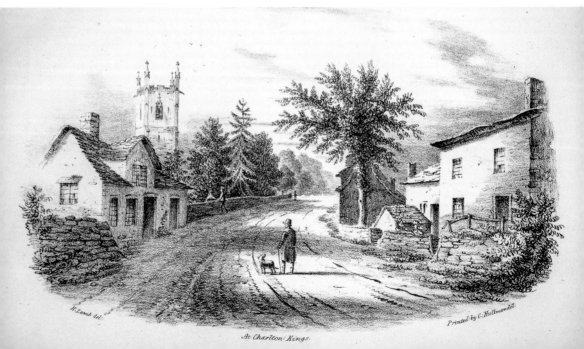

H. Lamb del. *Printed by C. Hullmandel.*

At Charlton Kings.

Regency and Beyond

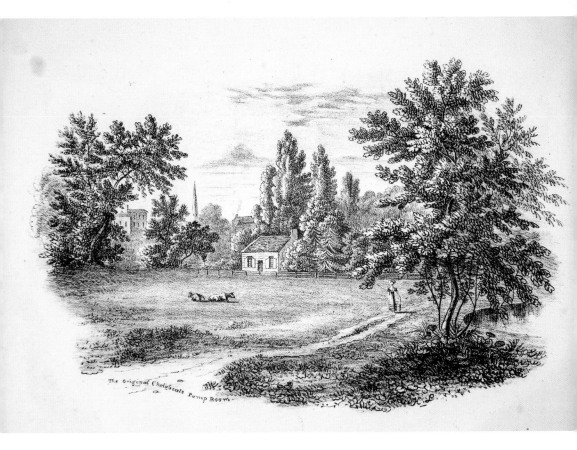

The Original Chalybeate Spa

This print *c.* 1825 by Henry Lamb shows one of Cheltenham's early and now forgotten spas, the Chalybeate Spa, part of which survives in Sandford Park. Opened in 1801 by the miller William Humphris Barrett at the start of the town's rapid rise as a watering place following King George III's visit, six years later it was renamed the Original Chalybeate Spa. By the 1850s it had become a private house.

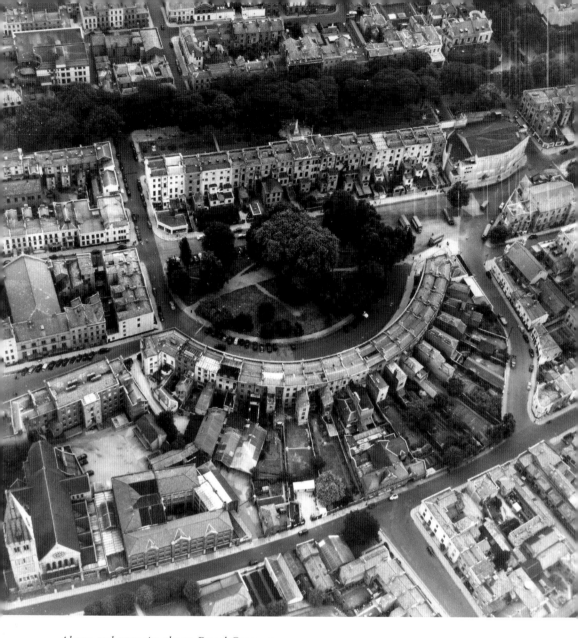

Above and opposite above: Royal Crescent

Ranking as Cheltenham's oldest surviving Regency buildings, this concave crescent of Regency houses was designed by the Bath architect Charles Harcourt Masters and built on the former Church Meadow. Constructed in stages from 1805 to the early 1820s as fashionable lodgings for visitors to the spa, it corresponds closely with equivalent crescents in other spa towns such as Bath and Leamington and helped set the architectural style for the developing town. Originally conceived as two blocks of twelve houses divided by a roadway, the structure was later adjusted to form a single crescent of eighteen houses. In 1806 No. 6 was put on the market as a fully furnished house comprising a drawing room, a breakfast parlour and nine bedrooms. (© Historic England Archive. Aerofilms Collection)

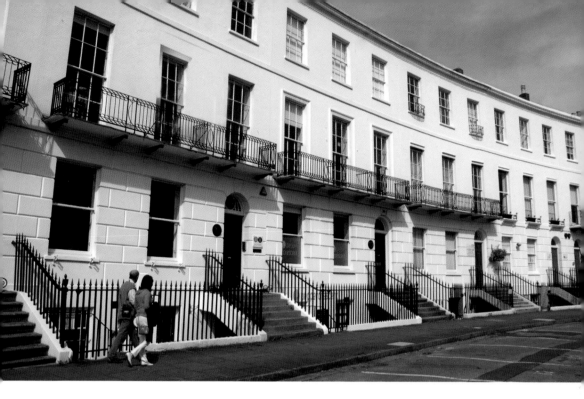

Below: Claremont Lodge
Located at the corner of Vittoria Walk and Montpellier Spa Road is one of the town's most highly regarded early Regency villas. Dating from *c.* 1813, with the upper storey added later, the bow-fronted villa includes a colonnaded Ionic porch at its side entrance, enhanced by four circular bullseye windows and recesses containing black urns. (Historic England Archive)

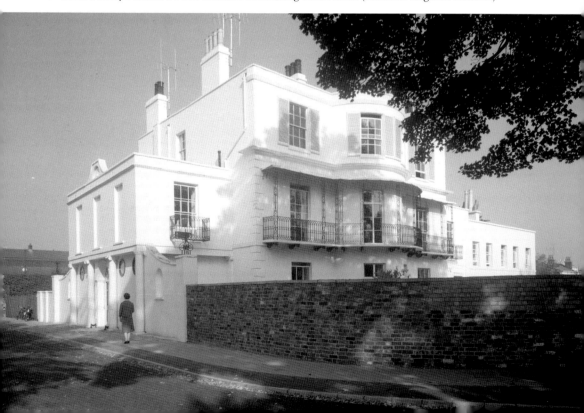

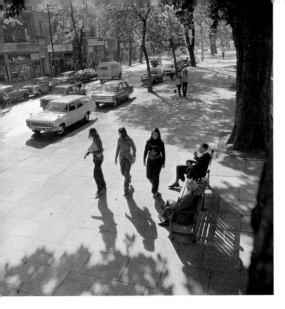
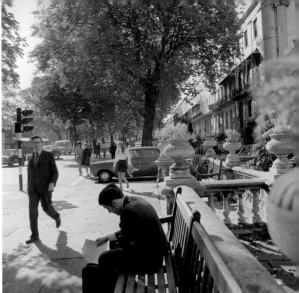

Above left and right: The Promenade, 1971

Before 1818, Cheltenham's most fashionable thoroughfare was nothing more than a scarcely passable marshy track, until the landowners Samuel Harward and Thomas Henney laid out a tree-lined avenue to connect the High Street with the Sherborne Spa (later the Imperial Spa) on the site now occupied by the Queens Hotel. By the end of the 1820s considerable development had taken place, including the establishment in 1826 of the Promenade's first shop, Cavendish House (then called Clark and Debenham), which still occupies its original, though now enlarged, site. While the Promenade is no longer used for the 'promenading' exercise necessitated by the taking of waters during Cheltenham's heyday as a spa, it is still a place for leisurely pursuits, including shopping. (© Historic England Archive)

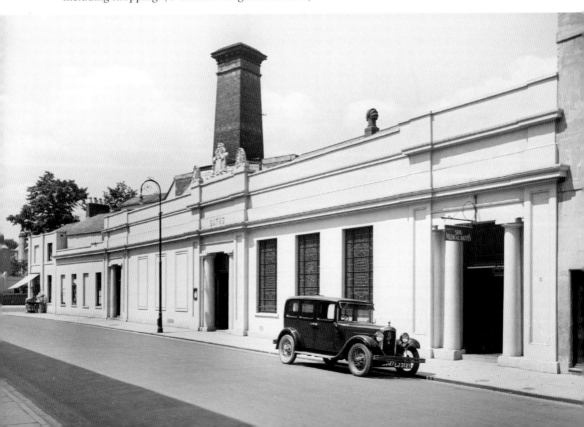

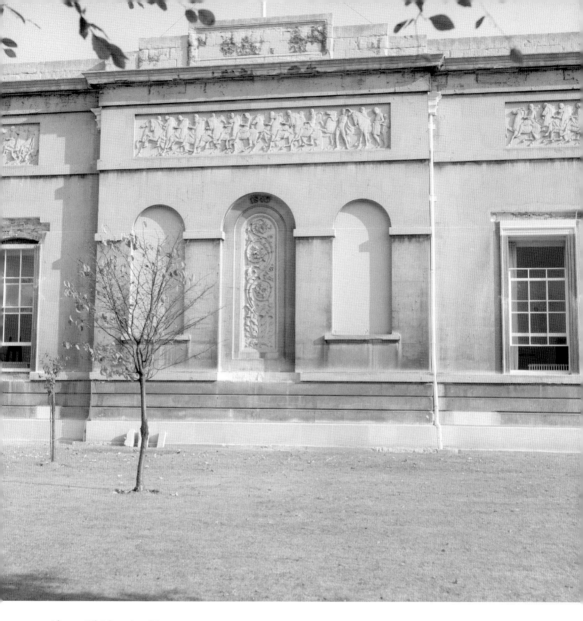

Above: Thirlestaine House
Dating from 1823, the house was designed by J. R. Scott, the original owner and an amateur architect who incorporated copies of classical carvings into its fabric. Later enlarged to house a nationally important collection of 1,500 old master paintings and then an extensive collection of books and manuscripts, it was subsequently acquired by Cheltenham College. (Historic England Archive)

Opposite below: Spa Medical Baths, Bath Road, 1933
Constructed in 1806–09 for the property developer Henry Thompson, who also developed Montpellier spa, the building was erected as baths (then called Montpellier Baths) and a salts manufactory. Hitherto, the Cheltenham waters had been for drinking rather than bathing. In 1900 it offered medical treatments and became a public swimming pool. From 1945 it has housed the Playhouse community theatre. (Historic England Archive)

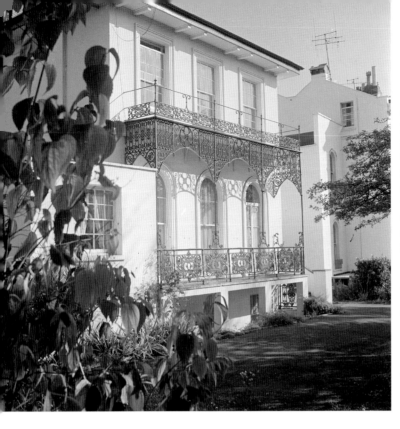

Garrondene
Located at No. 89 St George's Road, this villa with an ornate iron balcony was built *c.* 1840. Although Garrondene's ironwork dates post 1840, an earlier Cheltenham guide commented that 'The houses, verandas, and iron rails look as if they were composed of paper, silk and netting.' When it was advertised for renting in 1945, its accommodation included five bedrooms and three reception rooms. (© Historic England Archive)

Below left and right: Berkeley Place
These two photographs show the row of terraced houses at Berkeley Place (at the eastern end of the High Street), including a close-up view of their first-floor wrought-iron verandas with rod and concentric circle motifs on the balustrades and scroll motifs to the uprights. The street was named after the Berkeley family, who dominated much of Cheltenham's social and political life at the beginning of the nineteenth century. Colonel William Fitzhardinge Berkeley, the family's leading member, was responsible for transferring the Berkeley hunt to Cheltenham in 1809, and was one of the driving forces behind establishing regular horse racing here in 1819. (© Historic England Archive)

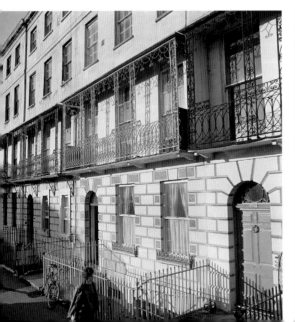
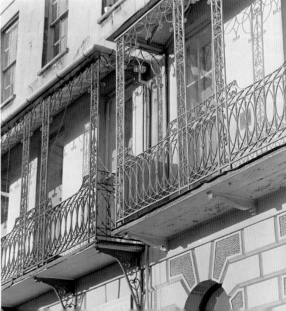

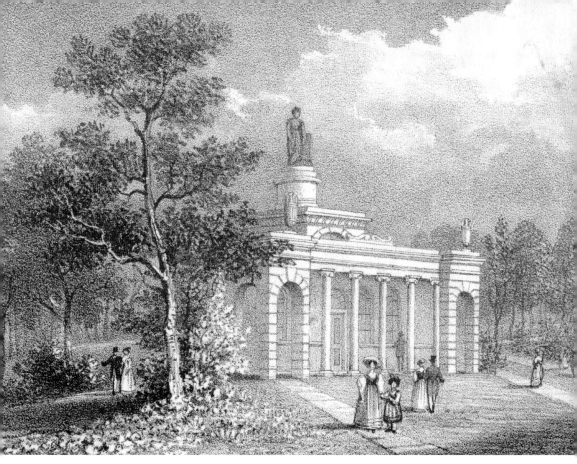

Above and right: Imperial Square
The square was conceived as part of the rides and walks developed for the Sherborne (later Imperial) Spa. As the early nineteenth-century print above shows, this spa featured a large statue of Hygeia, the Greek goddess of health, on its roof. Today, its site is occupied by the Queens Hotel. In the mid-1830s, the terraces on the north and east sides were built, providing lodging houses to help meet the growing demand from visitors. While the balconies no longer have uninterrupted views of the central gardens (see p. 68) because of subsequent construction of the Winter Gardens (no longer in existence) and the Town Hall, their iron railings display good examples of the 'heart and honeysuckle' motif produced by the Carron Company of Falkirk. (© Historic England Archive; Historic England Archive)

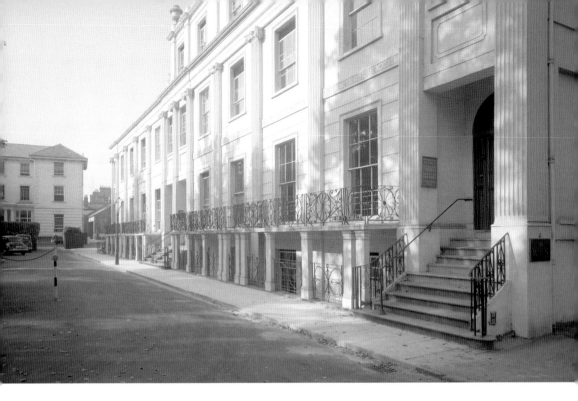

Wolseley Terrace
Located off Oriel Road, this terrace was completed in 1833. Described at the time by the local press as an 'elegant row of buildings', it was named after the Revd Sir Richard W. Wolseley, whose own residence, Wolseley House (previously known as Lindsay Cottage), was located further up Vittoria Walk/Trafalgar Street. Wolseley House was demolished to build the new terrace. (Historic England Archive)

Lawn Hotel, Pittville Lawn
Designed by Robert Stokes in 1833–34 as part of the original Pittville estate, this terrace includes No. 5, which was later converted into a hotel. Some houses in this section, originally known as Segrave Place after Colonel William Fitzhardinge Berkeley who became Baron Segrave in 1831, include verandas decorated with tent roofs and anthemion motifs (a design consisting of a number of radiating petals) on the uprights. (© Historic England Archive)

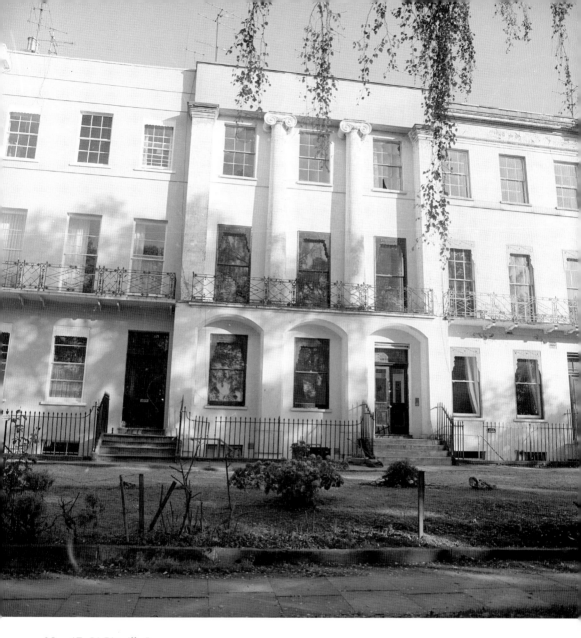

Nos 47–51 Pittville Lawn

This terrace of five houses was probably designed by John Forbes. No. 49 is noteworthy for Doric pilasters that frame two three-quarter-length Ionic columns. The ironwork of the balconies, carried out by William Montague and Charles Church of Gloucester, display a double lozenge motif. (© Historic England Archive)

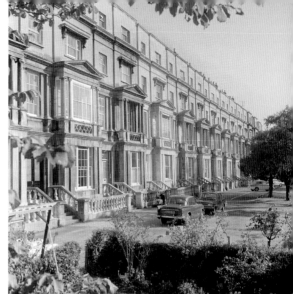

Above left: Alma House
Built in the mid-1830s as Rodney Villa, Alma House is one of Cheltenham's most individual buildings, combining elaborate classical Regency architecture with a stunning early twentieth-century interior scheme by Scottish designer George Walton. This photograph illustrates its fine façade, which includes a porch with four fluted columns. (© Historic England Archive)

Above right: Lansdown Terrace, 1971
Described by Verey as 'the most original terrace in Cheltenham', Lansdown Terrace was built between 1831 and 1848. The southernmost section (Nos 1–10) was completed first, followed by a middle section (Nos 11–22); a northward extension (comprising only No. 23) was never completed. Forming part of the Lansdown Estate, it was originally developed by Pearson Thompson. (© Historic England Archive)

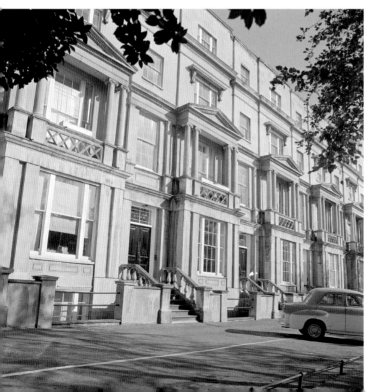

Evelyn Court, 1971
Comprising Nos 2–19 Lansdown Terrace and renamed Evelyn Court after being converted into apartments after 1918 by the Officers' Families Association, this terrace's main feature is the series of two-storey rectangular bays surmounted by dentil pediment. These fine buildings were designed by the brothers Robert and Charles Jearrad, who were adept at working in Greek, Gothic and Italianate styles. (© Historic England Archive)

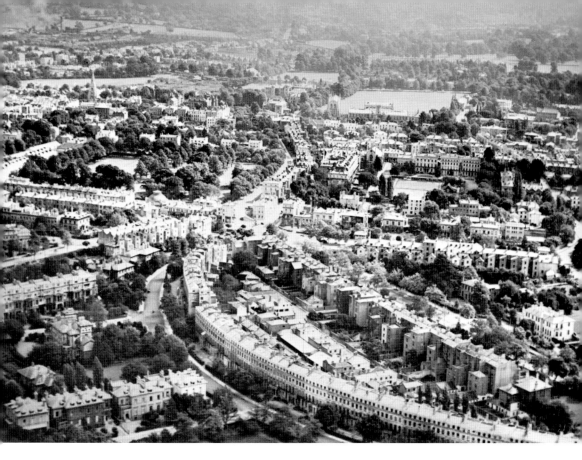

Lansdown Crescent, 1928
Originally this large convex crescent, which dates back to the 1830s and was 'without equal in its day', was conceived by its architect, John B. Papworth, as comprising semi-detached villas rather than a continuous terrace. When completed it was one of the largest crescents in the country, its chord line measuring 1,510 feet (460 metres). (© Historic England Archive. Aerofilms Collection)

Lansdown Crescent Lane, 1943
This photograph shows how little aesthetic architectural attention was given to the backs of even the finest Regency terraces. Viewed from the rear along its service road (unnamed on local maps until 1936), the magnificent convex design of Lansdown Crescent is hidden behind this seemingly mundane view. However, the rear service lanes of the grander terraces are interesting in their own right as examples of hierarchy and 'working' function of status town living. (Historic England Archive)

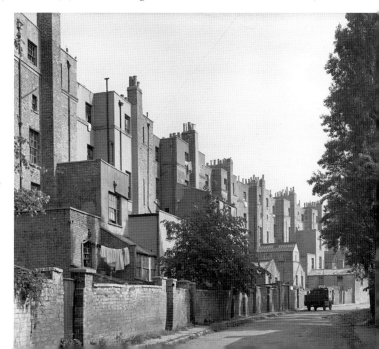

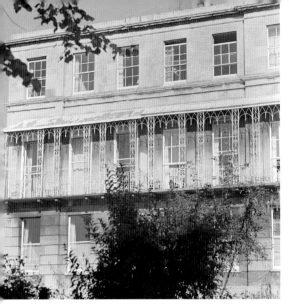
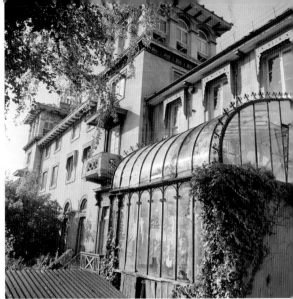

Above left: Lansdown Place, 1971
Comprising the earliest part of the Lansdown Estate, the town's first planned garden suburb, construction of the houses on Lansdown Place began in 1825. The balconies on the first floor are among Cheltenham's early examples of architectural cast ironwork and contain double-heart and anthemion motif balustrades, which later became a common feature in the town. (© Historic England Archive)

Above right: Victorian Conservatory, Lansdown Court
This 1970s photograph of a dilapidated conservatory illustrates how many of the large houses in Lansdown, which once epitomised nineteenth-century Cheltenham, proved too spacious for late twentieth-century living and started to fall into disrepair. Today, this semi-detached Italianate villa with a two-stage tower, originally built *c.* 1830–35, has been converted into apartments. (© Historic England Archive)

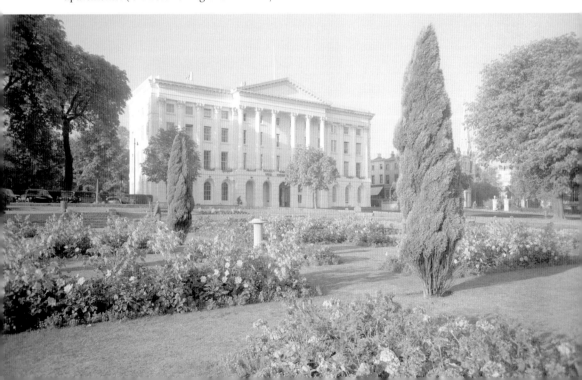

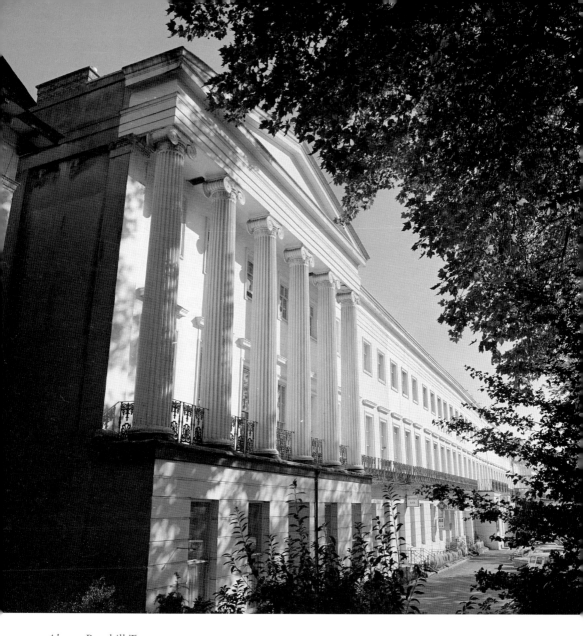

Above: Bayshill Terrace
One of Cheltenham's finest early Victorian terraces, which includes this pavilion with six fluted Ionic columns, was built on St George's Road *c.* 1838–45. Originally owned by the Skillicorne family, developers of the original spa, the area evolved as part of the Bayshill Estate. Today, the terrace is partly occupied by the George Hotel (Nos 41–49). (© Historic England Archive)

Opposite below: Queens Hotel
Built in 1837–38 on the site of the Sherborne Spa (later renamed Imperial Spa), the Queens Hotel was the biggest hotel in Britain when it was built. Its neoclassical grandeur, which includes a façade modelled on Rome's Temple of Jupiter, dominates the view at the southern end of the Promenade. (Historic England Archive)

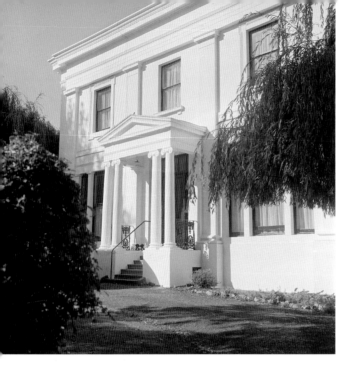

Hadley House, Bayshill Road
Built *c.* 1839–42, this villa is part of a 'superb group that make Bayshill Road one of the great roads for architecture in all England' (Verey). The house was home to Sir James Agg Gardner, the owner of the Cheltenham Original Brewery, and Dr C. B. Ker, a leading homeopathic physician who knew Alfred Lord Tennyson when he resided in Cheltenham.
(© Historic England Archive)

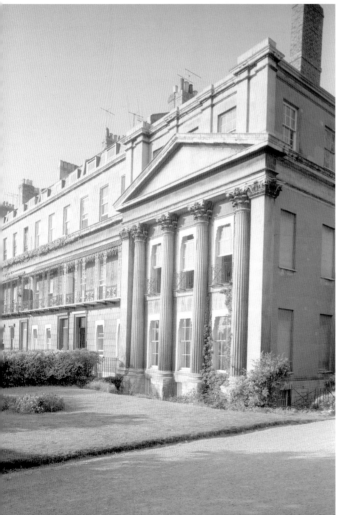

Suffolk Square
This residential square began to be developed from around 1823 after the local hotelier James Fisher bought land from the Earl of Suffolk. Many of the square's buildings were designed by the architect Edward Jenkins. The square's north terrace (shown in the photograph) was not completed until 1848, having been delayed by the 1825 banking crisis. (Historic England Archive)

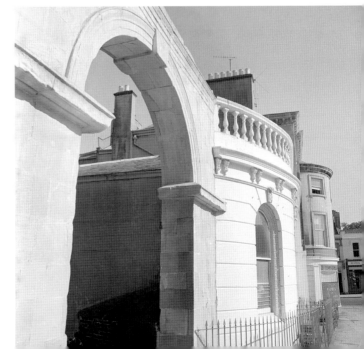

Tennyson's House, No. 10
St James's Square
Once described as a 'tall, old-fashioned villa, built in the most approved doll's house style of architecture', this is where the poet Alfred Lord Tennyson lived from 1846 to 1850. Still mourning the death of his beloved Cambridge friend Arthur Hallam, it is belived that Tennyson wrote part of *In Memoriam* (1849) here.

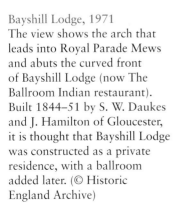

Bayshill Lodge, 1971
The view shows the arch that leads into Royal Parade Mews and abuts the curved front of Bayshill Lodge (now The Ballroom Indian restaurant). Built 1844–51 by S. W. Daukes and J. Hamilton of Gloucester, it is thought that Bayshill Lodge was constructed as a private residence, with a ballroom added later. (© Historic England Archive)

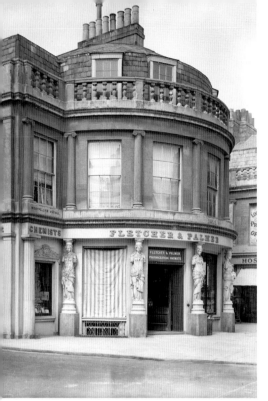
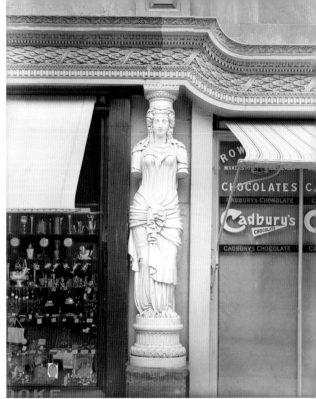

Above left and right: Caryatids
One of the distinctive features in Montpellier Walk are the thirty-two armless white caryatid figures that provide support to the shop lintels. Based on the design of the caryatids supporting the Erechtheion temple's portico on the Athenian Acropolis, three original Cheltenham figures were made for Pearson Thompson in terracotta by the London sculptor Rossi. The others were copied in stone by local craftsmen James Brown and his son William, and two recently reproduced in concrete. The origin of the caryatids' use appears to derive from an ancient Greek victory over the Carian people who had sided with the Greeks' enemies. Following the conquest, the Greeks enslaved the Carian women and, to further perpetuate the Carians' disgrace, used their figures as architectural columns in public buildings. (Historic England Archive)

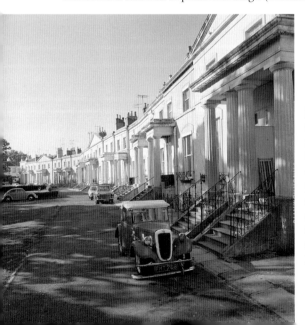

Lansdown Parade
Originally referring to a terrace of twenty-three houses built *c.* 1835–41 with Greek Doric porches, the road now includes other houses. During the 1970s, when this photograph was taken, the borough council agreed to pay £2,000 compensation for the compulsory purchase of No. 22, which had fallen into disrepair, so that the whole terrace could be adequately restored. (© Historic England Archive)

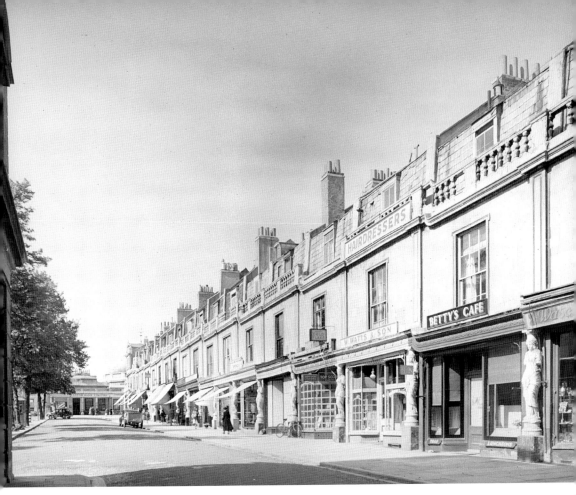

Above and right: Montpellier Walk
Established as a tree-lined walk for visitors to Montpellier spa *c.* 1809, this thoroughfare was originally known as Montpellier Promenade. An 1843 guidebook commented,

> There are few scenes more animated and inspiring than the Montpellier promenade, on a fine summer morning, between eight and ten o'clock. The presence of the lovely, the titled, and the fashionable, as they parade up and down the grand walk to the sound of music, and breathing an atmosphere of sunshine and health...

Following the development of the spa, a number of small shops were also established nearby, leading Montpellier to become the specialist shopping area that it continues to be today. (© Historic England Archive; Historic England Archive)

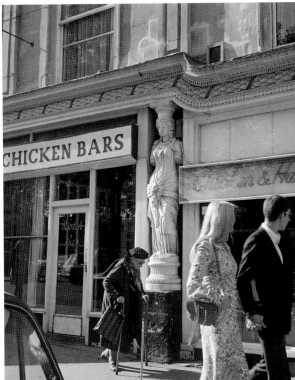

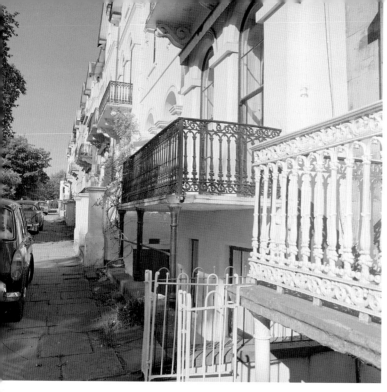

York Terrace
Originally comprising fourteen houses, which now correspond to the present Nos 59–87 St George's Road, this terrace was built *c.* 1848–53. Its Italianate style contrasts with the classical style of the neighbouring Bayshill Terrace. The attractive ironwork of its railings and balconies includes the Greek key pattern at No. 87. (© Historic England Archive)

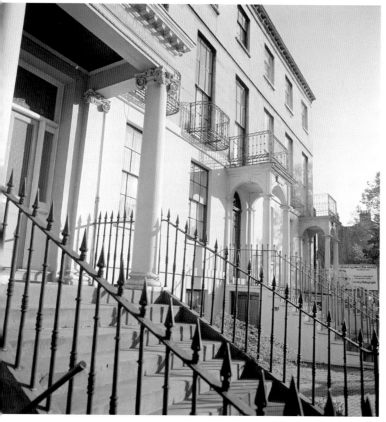

Sussex House and Bordeaux House, Winchcombe Street
Built in the mid-nineteenth century, this pair of terraced houses feature distinctive entrances comprising porches with Doric columns and engaged pilasters accessed via flights of roll-edged steps. During the First World War, Sussex House (on the left) was run as a hotel, where the French sculptor Auguste Rodin stayed in 1914. (© Historic England Archive)

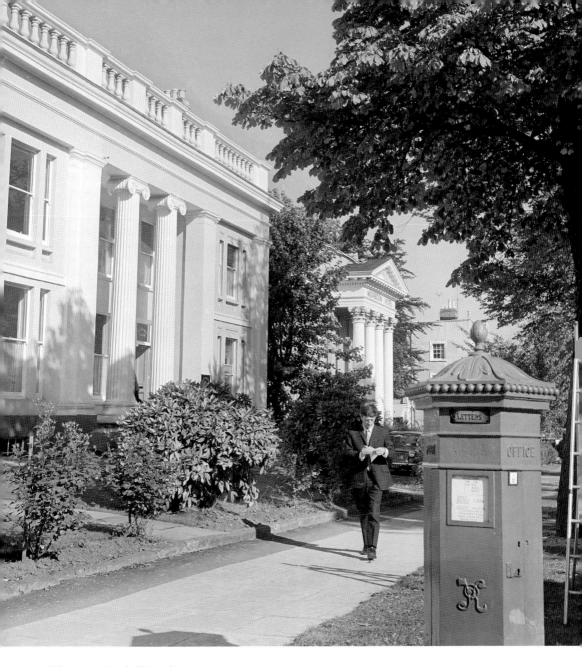

Pillar Box, Bayshill Road

Next to Lingwood House, which today forms part of the Parabola Arts Centre, is a hexagonal Victorian pillar box designed by the architect John Penfold, one of nine in Cheltenham and only ninety-two in the whole country. Cheltenham was one of the early pioneers of pillar letter boxes, in 1854 boasting their installation eight months before London. (© Historic England Archive)

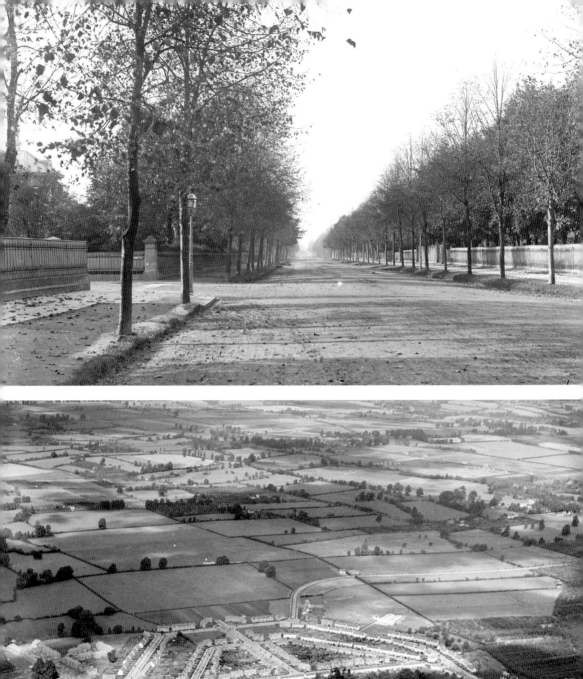
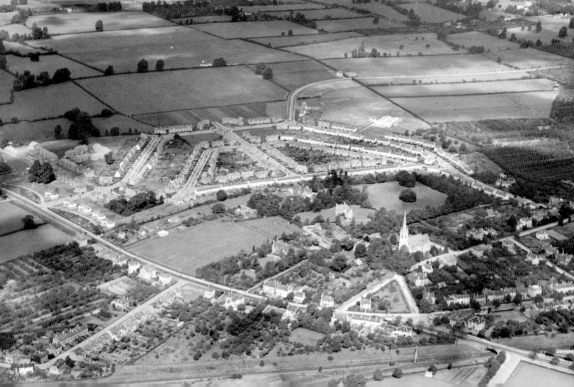

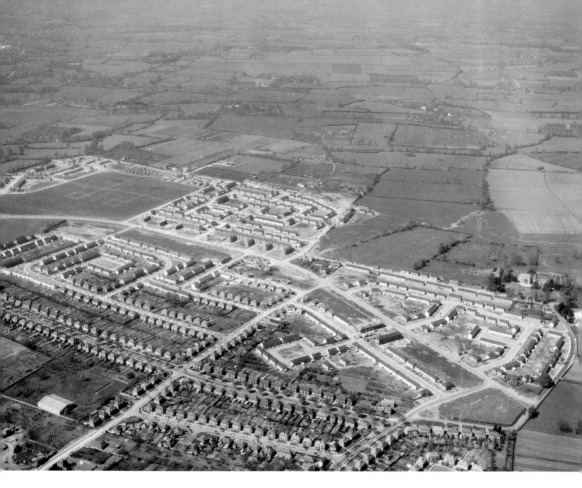

Above: Hester's Way Estate, 1953
Originally deriving its name from an enclosure called (H)Ayster's Way, Hester's Way Estate is one of the largest post-war housing developments on the town's western side. House construction began in 1951, the first turf being cut by the then Princess Elizabeth, leading to the completion of 3,000 homes by 1960. (© Historic England Archive. Harold Wingham Collection)

Opposite above: Queen's Road, 1890
The Birmingham and Gloucester Railway bought the land *c.* 1839 and widened the approach to the (future) Lansdown station. In the 1860s the town commissioners took it over and began building houses here. Named after Queen Victoria, the road previously followed the line of a tram road for horse-drawn trams that linked Westal Green with Gloucester Road, and Leckhampton quarries with the tramway to Gloucester. (Historic England Archive)

Opposite below: St Mark's Estate, 1928
The post-war need for more housing, allied to a programme of slum clearance, led the town council to develop new estates on the western edge of town. These included a new garden suburb near St Mark's Church known as 'The Poets'. The area's roads were named after English poets, such as Milton and Tennyson, some of whom were associated with the town. (© Historic England Archive. Aerofilms Collection)

Places of Worship

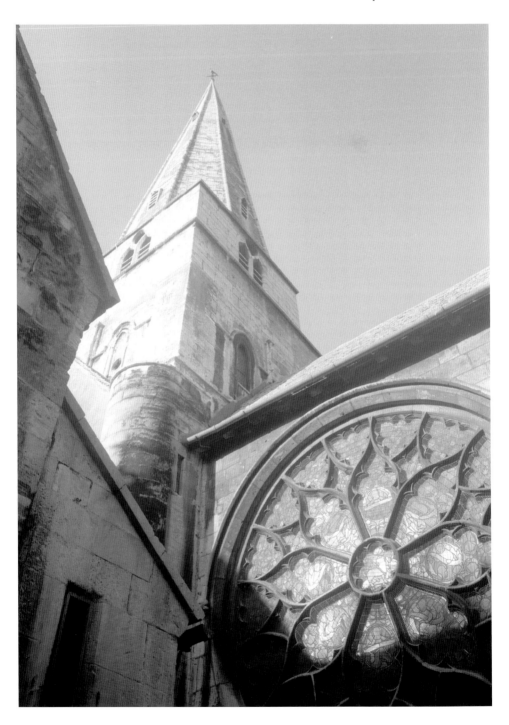

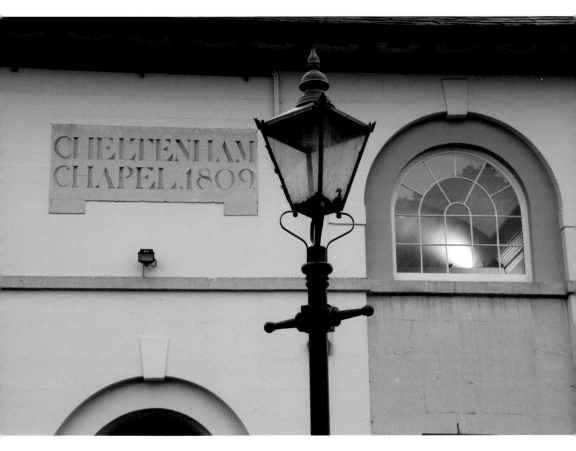

Above: Cheltenham Chapel
Converted into offices today, Cheltenham Chapel was once an important focal point for the town's religious fervour. Built in 1809, it is the town's earliest surviving chapel used by nonconformists. One of its preachers, Rowland Hill, was a friend of Dr Edward Jenner, the pioneer of vaccination. Through their friendship vaccination clinics were held in the chapel on Sundays.

Opposite: St Mary's Church
Renamed Cheltenham Minster in 2013, St Mary's is Cheltenham's oldest building, some of its arches dating from *c*. 1170. The building possibly replaced a Saxon church erected four centuries earlier. The photograph includes a view of the rose window featuring fourteenth-century tracery and Victorian glass. Inside is a remarkable memorial, the longest in the country, to Henry Skillicorne, the developer of Cheltenham's first spa. (Historic England Archive)

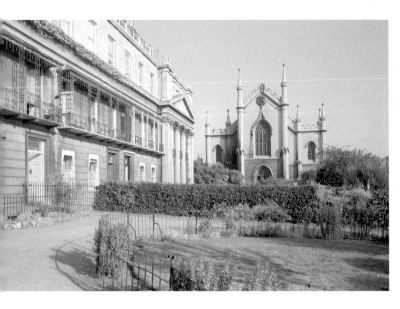

St James's Church
Originally consecrated in 1830, the church was built for the developer James Fisher. It is claimed that the church could originally accommodate 1,500 people, the majority of seats being owned by the affluent inhabitants of Suffolk Square. Today, converted into a restaurant, its Gothic Revival architecture contrasts with the predominantly neoclassical buildings in the area. (Historic England Archive)

Holy Trinity Church
Opened in 1823, this was the first new church to be built in Cheltenham since medieval times. It was also the first church in the town to operate on the proprietary system whereby the use of pews was bought on a shareholding basis. Many of the church's 181 stone tablets commemorate Cheltenham's Anglo-Indian connections.

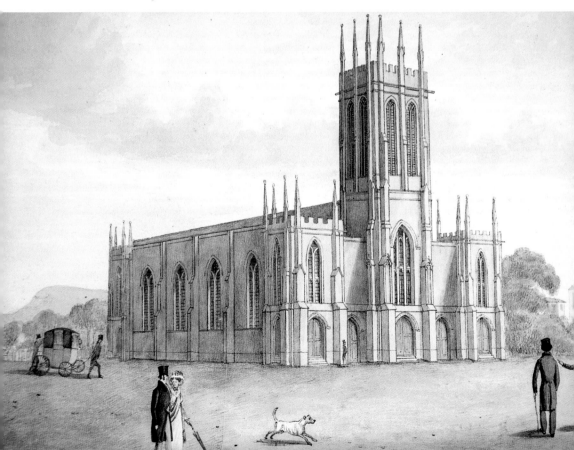

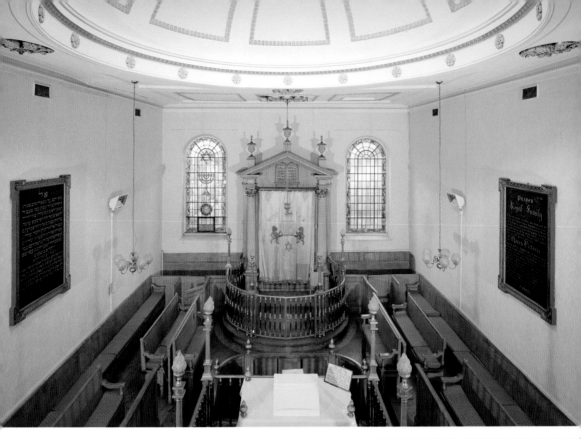

Above and right: Synagogue
Recognised as an excellent
example of a small provincial
English synagogue, Cheltenham's
synagogue was designed by
W. H. Knight, who also designed
the town's public library. It opened
in 1839 to cater for the growing
Jewish population, which had been
attracted to the town following
King George III's visit in 1788. Its
Ashkenazi furniture, which includes
this seating, is the oldest in the
country. Dating from 1761, the
furniture was originally installed
at the Leadenhall synagogue,
London, and later transferred to
Cheltenham. The dome, part of
which is visible in the interior
view above, was described by the
Cheltenham Free Press as being
'finished in a superior manner
with cornice and fretwork'.
(© Historic England Archive)

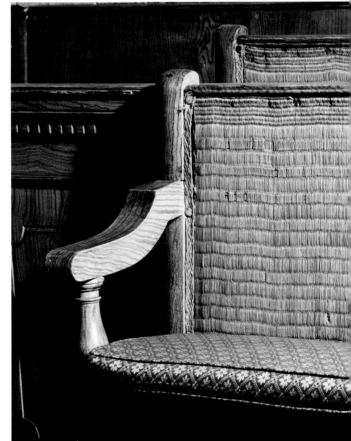

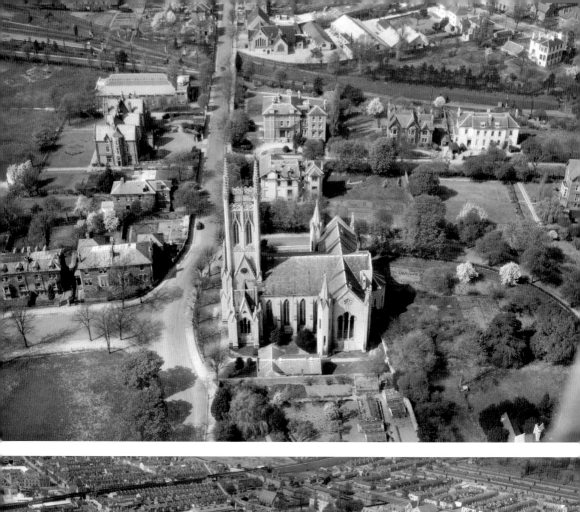
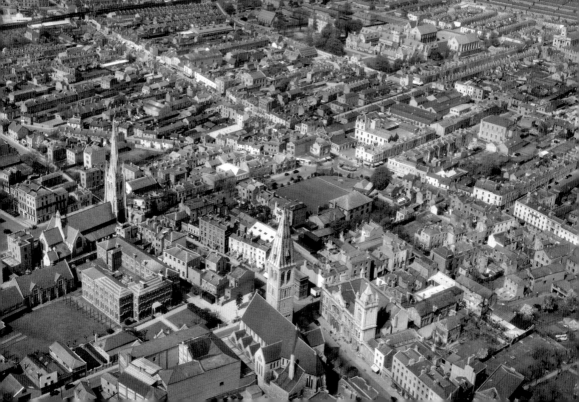

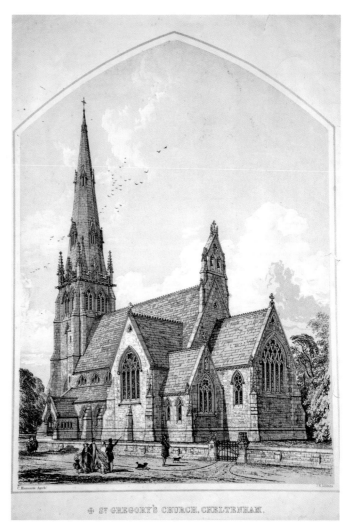

St Gregory's Roman Catholic Church
Dating from 1854, the Decorated Gothic-style church was built on the site of an earlier chapel of 1810. Its 208-foot-high spire (41 feet higher than Cheltenham Minster) provides an indication of the town's early large Catholic population, which developed in particular during the French Revolutionary and Napoleonic Wars as exiles settled in Cheltenham.

Opposite above: Christ Church, 1952
As Cheltenham's population increased tenfold between 1800 and 1840, several new churches were built. Among these was Christ Church, which was developed by Francis Close for the poor district of Alstone. It was consecrated in 1840 but, unusually, this was before the surrounding houses were built. Many memorials inside show Cheltenham's connections with India and the Bengal Civil Service. (© Historic England Archive. Harold Wingham Collection)

Opposite below: St Matthew's Church, 1952
Located bottom centre in the photograph, St Matthew's Church was built in 1879 in the Gothic Revival style on the site of the Great House. It replaced a corrugated building that had been erected for temporary use while St Mary's Church was being restored. In 1952 the church's spire was removed and in 1972 its tower lowered. (© Historic England Archive. Harold Wingham Collection)

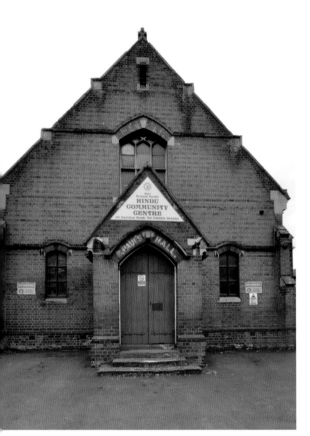 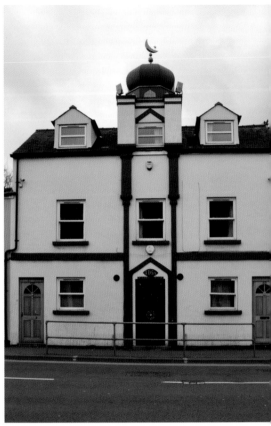

Above left: Hindu Community Centre
Located in Swindon Road, the community centre, which includes a Mandir (temple), was opened in 1986, after an earlier temple was established in 1975. The first Hindu immigrant moved to Cheltenham in 1956. In 2003 there were approximately 350 Hindu families with 800 people living in Cheltenham.

Above right: Masjid Al-Falah
Masjid Al-Falah is located on Lower High Street and can accommodate 220. The town's other Mosque, Masjid Al-Madina, is located at No. 25 Sherborne Place.

Public Buildings

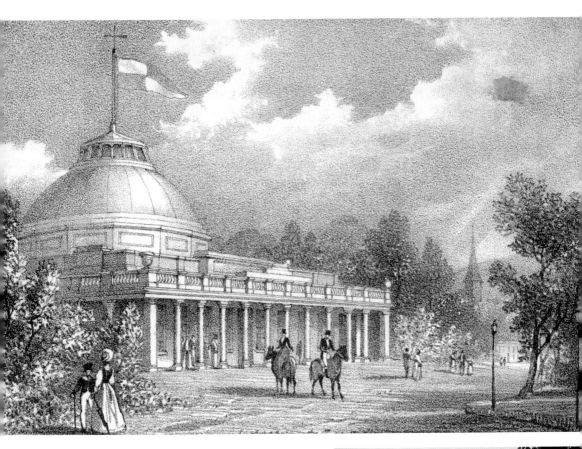

Above and right: The Rotunda
Until recently a branch of Lloyds Bank and latterly converted into a restaurant, this building was originally developed as the Montpellier Spa by Henry Thompson in 1809. Initially it was a simple cottage orné with wooden pillars. This was later replaced with a more elaborate stone building that could be used for balls and assemblies. In 1825 Henry's son, Pearson Thompson, commissioned the celebrated London architect J. B. Papworth to add a dome to the building and henceforth it became known as the Rotunda, as illustrated in this early nineteenth-century print. Measuring 50 feet in diameter, the interior of the dome was partially inspired by the Pantheon in Rome. (Historic England Archive)

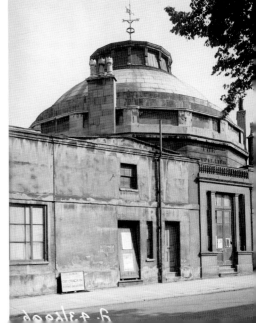

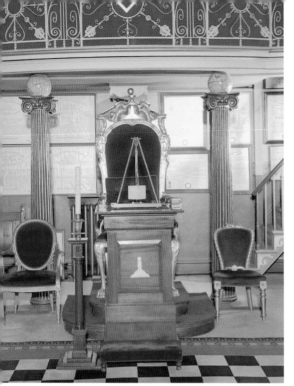

Left and below: Masonic Hall
Located in Portland Street and built between 1820 and 1823 by George Underwood, a Freemason himself, this was the world's first purpose-built Masonic Hall outside London, and today has the distinction of being Cheltenham's oldest non-ecclesiastical public building still in use for its original purpose. As one of the oldest secular fraternities in the world Freemasonry has had a permanent presence in Cheltenham since 1817. Its association with the town was first established following the transfer of one of the foundation lodges dating from 1753 from London and then Abingdon. As these two photographs illustrate, it has a richly decorated interior, including Cheltenham's oldest organ (not shown) dating from before 1832. (Historic England Archive)

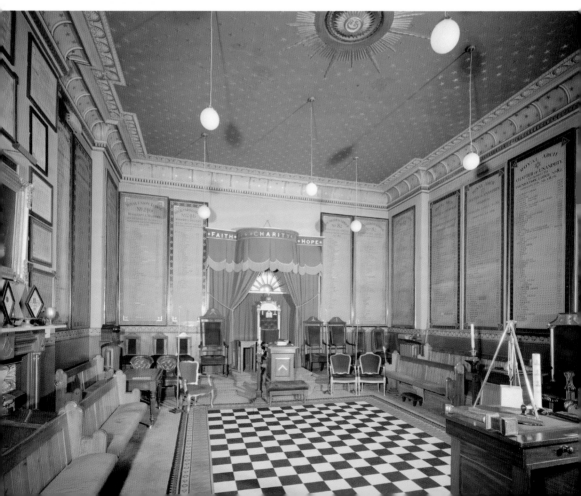

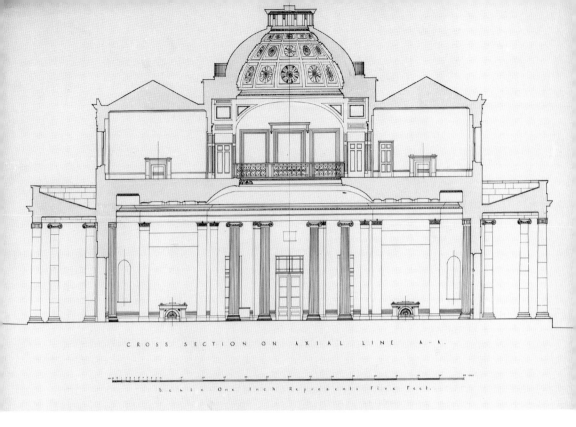

CROSS SECTION ON AXIAL LINE A-A.

Scale One Inch Represents Five Feet.

Above and below: Pittville Pump Room

Often considered Cheltenham's finest Regency building, the pump room was commissioned in 1825 by the lawyer and wealthy landowner Joseph Pitt as the focal point for his intended new town of Pittville. Designed by John Forbes, it took five years to build. Its impressive Ionic columns were based on the Athenian Temple on the Ilissus. Besides dispensing water for visitors to the spa, in the early days it also provided them with entertainment such as assembly balls, card games and billiards, and walks in its pleasure gardens. Despite its magnificence it could not halt the decline in fashion for taking the waters that occurred during the 1830s. (Historic England Archive)

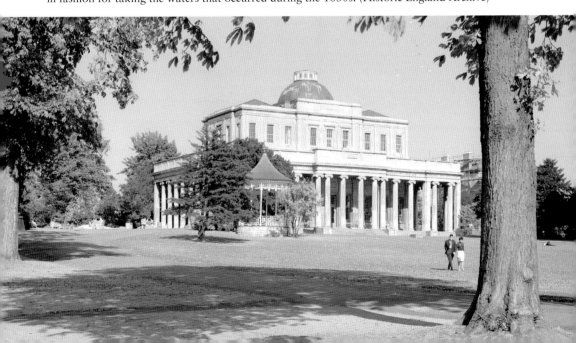

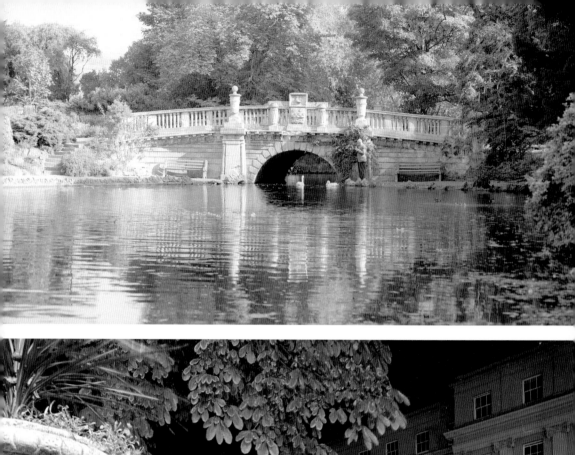

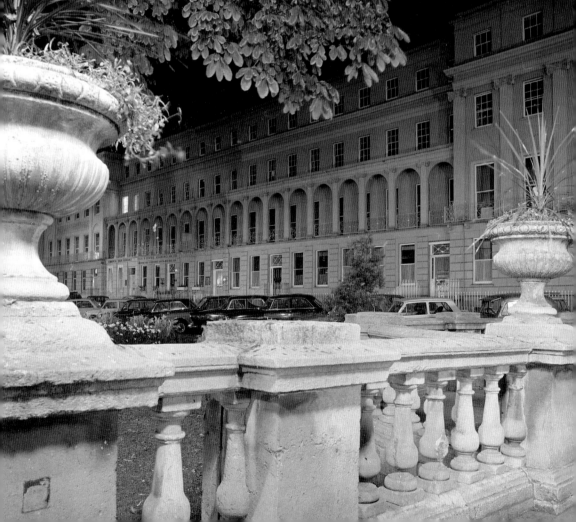

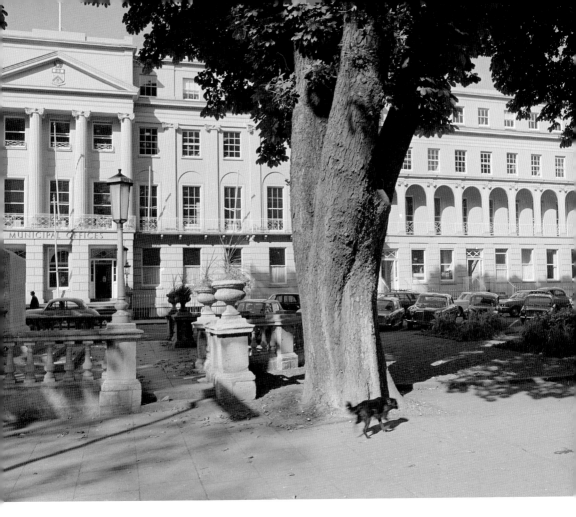

Above and opposite below: Municipal Buildings, 1971

The magnificent terrace on the west side of the Promenade, considered by some architectural historians to be 'equal to any in Europe', is today largely occupied by the Municipal Offices. Originally called Harward's Buildings, it was named after Samuel Harward, an enterprising businessman who helped develop both the Promenade and the Sherborne Spa at the beginning of the nineteenth century. Although it was designed in 1822–23, probably by George Allen Underwood, the sixty-three-bay-long, three-storey-high terrace was not completed until *c*. 1835. Initially, it was used for residential purposes. However, by the beginning of the twentieth century it had become largely commercial and from 1914 onwards the central houses were acquired for conversion into council offices. (© Historic England Archive)

Opposite above: East Bridge, Pittville Lake

Designed by John Forbes, the architect of Pittville Pump Room and nearby St Paul's Church, the bridge on the eastern side of the lake is one of a pair of twin stone bridges completed in 1830 at the same time as the pump room. Both bridges are Grade II listed and include balustraded parapets and urns. (Historic England Archive)

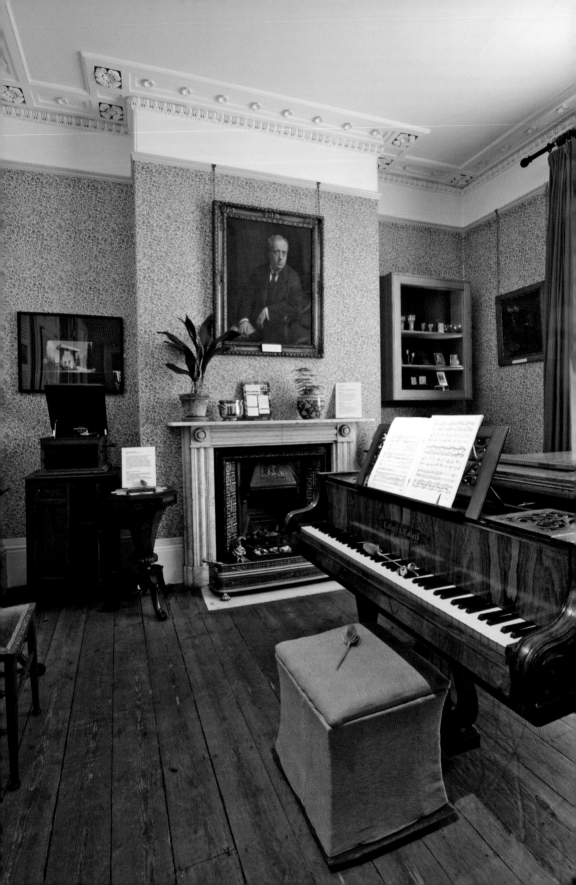

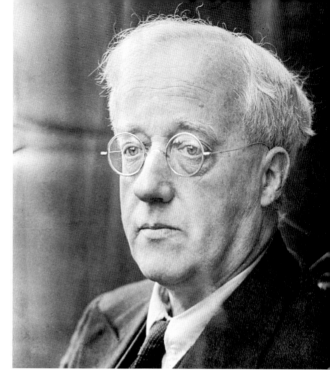

Opposite and right: Holst Birthplace Museum

The terraced house at No. 4 Pittville Terrace (now Clarence Road), currently the only Regency house open to the public in the town, was where the composer Gustav Holst was born on 21 September 1874. He lived there for seven years until the death of his mother in 1882. Originally built in 1832 as part of the Pittville Estate, the small Regency house is now a museum, run by an independent trust, and celebrates his life and work through temporary and permanent displays, which include the piano (see photograph opposite) on which much of *The Planets*, his most celebrated work, was composed. (© Historic England Archive)

Below: Former County Court

Completed in 1871, the Italian Renaissance-style building was used as a court for the recovery of small debts until the beginning of the twenty-first century. Although latterly a restaurant, little alteration has occurred and it remains one of the best-preserved examples of the style and layout of county courts of the middle of the nineteenth century.

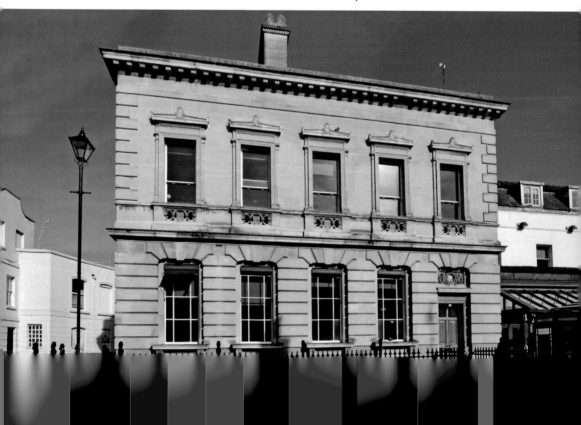

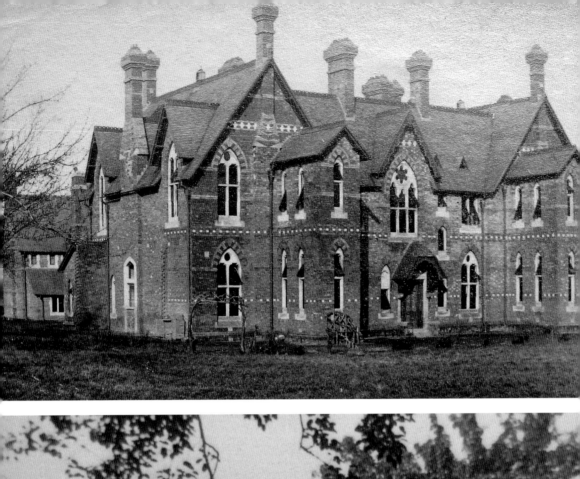

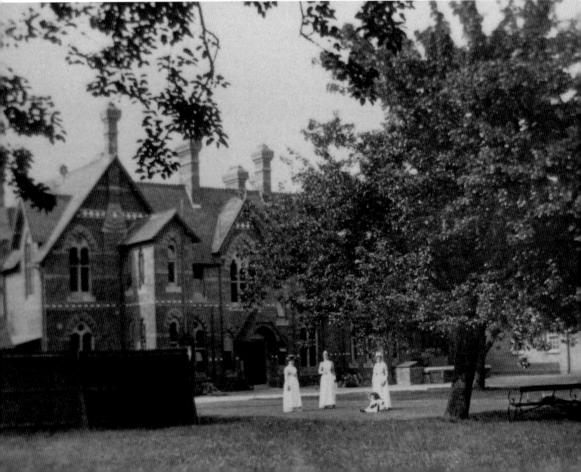

Above: Former Cheltenham College Swimming Baths
Used today by the East Gloucestershire NHS Trust as a repository for health records, this building was originally a college and then public swimming baths. Designed in 1879 by W. H. Knight, it had one large pool, which was lined with white-glazed tiles, as well as fifty changing cubicles, towel washing and drying rooms, and maintenance rooms.

Opposite above and below: Delancey Hospital, Charlton Lane
Designed by John Middleton, Delancey Hospital opened in 1874 as a hospital for fever and other infectious disease. It was named after the benefactor, Miss Susan Delancey, who bequeathed £5,000 in 1866 for this purpose. Dr Edward Thomas Wilson, father of the famous Antarctic explorer (see p. 56), was deeply interested in public health and was largely responsible for the establishment of the hospital and its management for nearly fifty years. The contribution that the hospital made to the health of the town was significant: the smallpox block alone, for example, which was opened in 1874, succeeded in protecting the town from that disease for over forty years. In 2013 the buildings were converted into apartments.

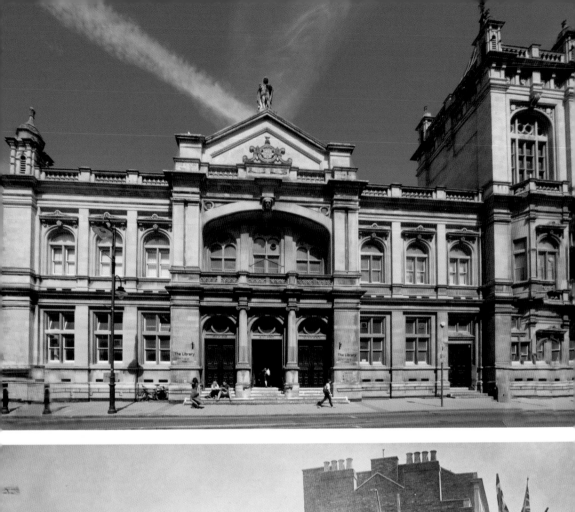
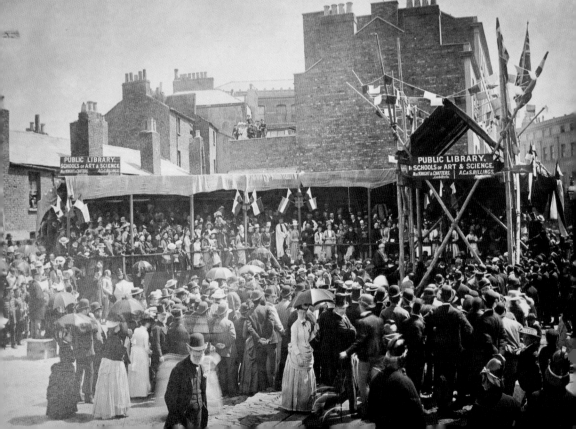

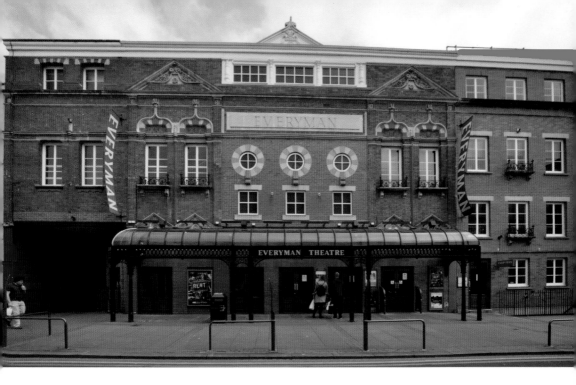

Above: The Everyman Theatre
Opened in 1891, Cheltenham's Everyman (then known as The New Theatre and Opera House) is the oldest surviving example of Frank Matcham's design. Although the theatre prospered during the first half of the twentieth century, in 1959 the increasing popularity of television threatened its closure. To revive its fortunes, in 1960 it was relaunched as the Everyman.

Opposite above and below: Public Library
Although Cheltenham's first public library was established in 1884 in Liverpool Place in the High Street, it moved to its present site in Clarence Street (then called Manchester Street) following construction in 1887–89 of a new purpose-built building (see photograph above) designed by the local architect W. H. Knight. A late addition to the design was the inclusion of a tower to enhance the appearance through breaking up the severe line of the roof. Known as the Jubilee Tower, having been funded through subscriptions raised for Queen Victoria's Golden Jubilee, a 3-ton block from Cleeve Hill was laid as its foundation stone to mark the celebrations on 21 June 1887.

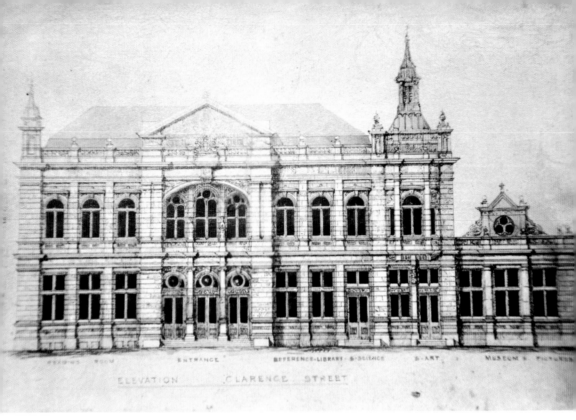

ELEVATION CLARENCE STREET

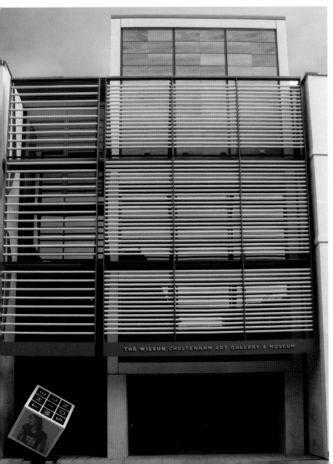

THE WILSON CHELTENHAM ART GALLERY & MUSEUM

Above and left: The Wilson
Cheltenham's first public art gallery
was opened in 1899 following the
donation of forty-three old master
paintings by Baron de Ferrières, a
former mayor and MP for the town.
Eight years later, the town's public
museum was opened on the first floor
of the library building (the original
architectural drawing is above).
Today, the art gallery and museum
is known as The Wilson following a
£6.3 million extension in 2012–13.
The name was inspired not only
by Cheltenham's famous Antarctic
explorer Dr Edward Wilson, who
perished with Captain Scott at the
South Pole in 1912, but also by his
father, Dr Edward Thomas Wilson,
who campaigned vigorously for the
museum and officiated at its opening
on 20 June 1907.

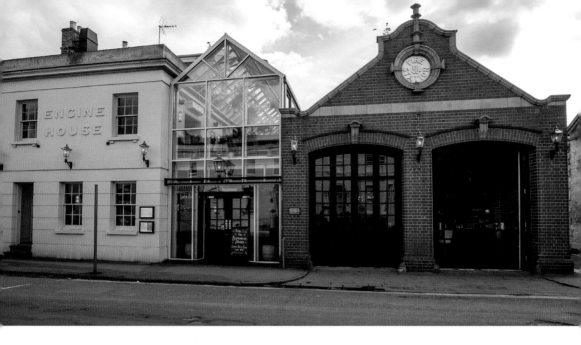

Above and below: The Fire Station

Cheltenham's old fire station, now converted into a restaurant (see photograph above), was built in 1906. Located in St James's Square, it replaced an earlier station of *c.* 1840, which is situated immediately adjacent and is still identifiable through 'Engine House' emblazoned on its front façade. Upon its opening (see photograph below), the station was equipped with three fire engines, the largest of which was a Merryweather 360-gallon steam machine, complete with 300 yards of hose. The entire workforce consisted of twenty-three men, described as 'a sturdy set of fellows'. The station remained operational until 1959 when new headquarters were opened in Keynsham Road.

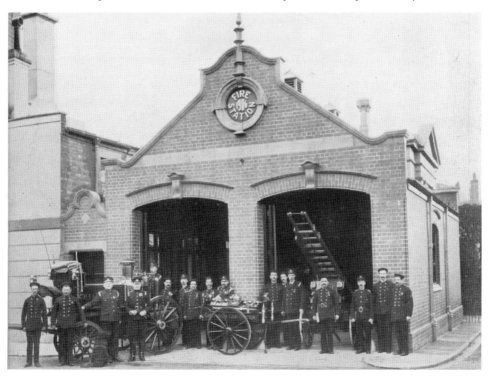

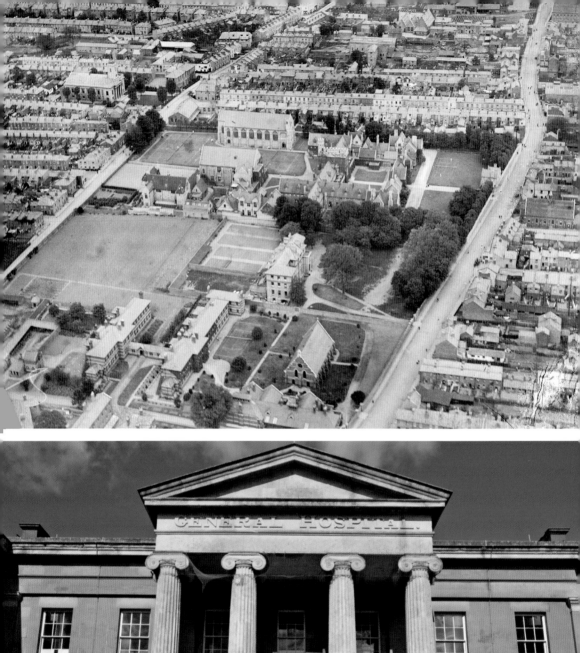
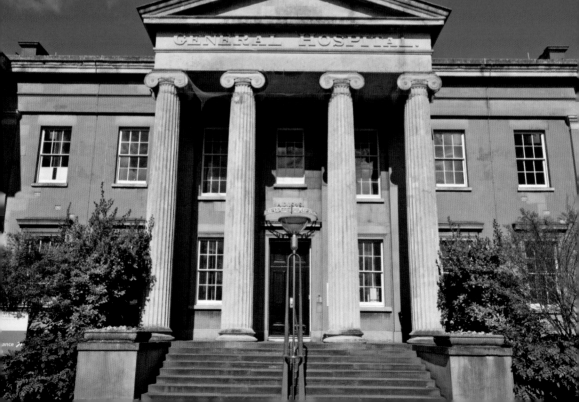

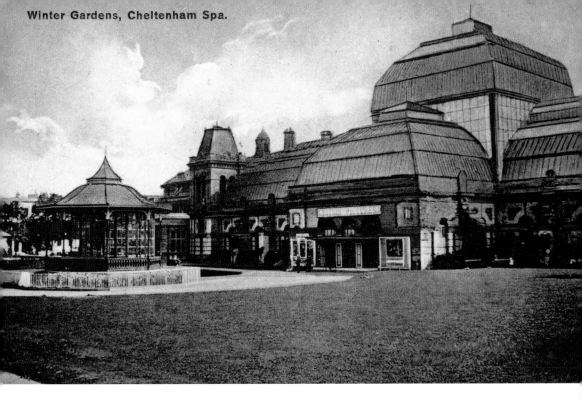

Winter Gardens, Cheltenham Spa.

Above: Winter Gardens
Behind the Town Hall was the site of the Winter Gardens, Cheltenham's 'Crystal Palace'. Built in 1878 as a venue for events, it was demolished in the early 1940s. Despite this, signs are still visible of its former existence through the layout of the paths in the ornamental gardens, which align with the position of the Winter Gardens' entrances. (Historic England Archive)

Opposite above: Cheltenham Union Workhouse and St Paul's Training College, 1920
In 1834 the Poor Law Amendment Act led to the creation of new central workhouses. Initially housing 581 inmates, Cheltenham's 'union house' opened in 1841 and was located adjacent to St Paul's Training College for Teachers. Later, the workhouse was converted into St Paul's Maternity Hospital, and then demolished in the late 1990s. (© Historic England Archive. Aerofilms Collection)

Opposite below: General Hospital
Cheltenham's General Hospital was built in Sandford fields in 1848–49 to replace Segrave House (now Normandy House) in the Lower High Street and serve the town's increasing population, which by 1841 had reached 36,000. It was the last important classical-style building to be erected in the town and was designed by D. J. Humphris, who later became the borough surveyor.

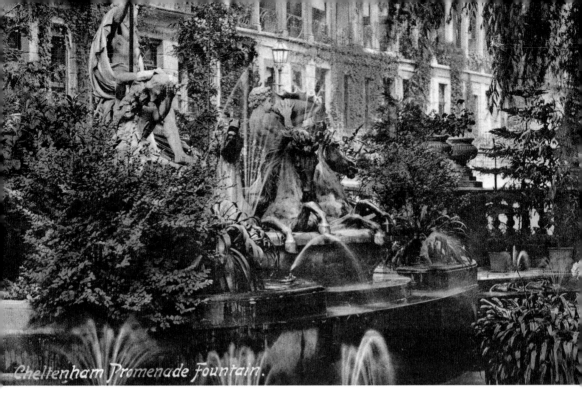

Above and below: Neptune Fountain

Based on the borough surveyor's design of Rome's Trevi Fountain, this sculpture shows Neptune, the Roman god of the sea, with seahorses and tritons. Erected in 1893, the fountain is fed from the River Chelt, which lies directly underneath. In 1933, from which the black and white photograph below dates, the fountain was surrounded by a weeping willow thought to have been grown from a cutting of a specimen brought from Napoleon's tomb at St Helena. However, a year later the *Cheltenham Chronicle* reported that 'Cheltenham's famous weeping willow which for many decades has formed a graceful canopy over Neptune's Fountain ... is in the hands of the executioner'. Planted in 1860, the willow lasted for seventy-four years. (Historic England Archive)

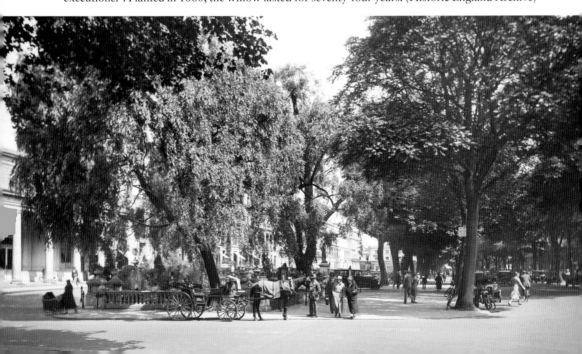

Right and below: Town Hall
Cheltenham's Edwardian baroque
Town Hall was built in 1903 as the
major venue for the town's cultural
life, replacing the Assembly Rooms
in the High Street, which were
demolished in 1900. The building
was designed by Gloucester architect
Frederick William Waller and built at
a cost of £45,000. Significantly, the
building is also the site of the Central
Spa, which was opened in 1906 as
part of the Corporation's attempt to
revive the custom of taking the waters.
To the left of the entrance hall is an
octagonal counter with four elaborate
Doulton ware urns, only one of which
now has a tap (non-functioning) for
dispensing the water. Originally, it
dispensed different types of mineral
water, from both Montpellier and
Pittville. (© Historic England Archive)

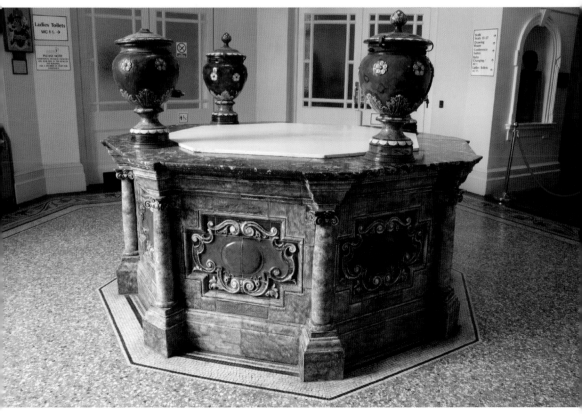

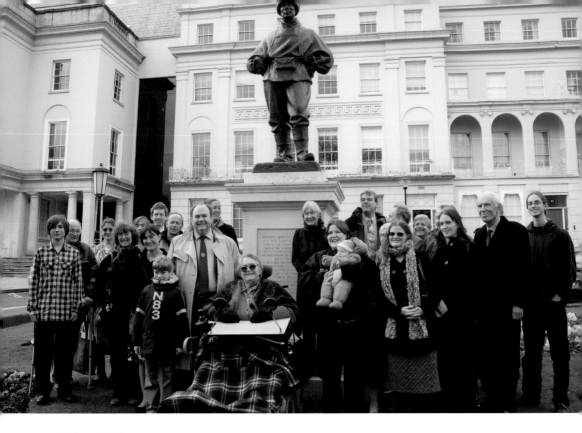

Edward Wilson
Edward Wilson is one of Cheltenham's most famous sons. Born in 1872 at a house in Montpellier Terrace, he accompanied Scott on his two Antarctic expeditions. The photograph shows the rededication of Wilson's statue on the Promenade in 2012, marking the centenary of Wilson's death near the South Pole. Three generations of the Wilson family are present.

Edward VII Drinking Fountain
Located in Montpellier Walk, the statue depicts the king dressed in a Norfolk suit, representing 'the Spirit of Peace leading the Spirit of Mischief [represented by a barefoot waif] to the still waters'. Originally unveiled in 1914, it was donated by Mr and Mrs Drew of Hatherley Court, who were known for rescuing retired horses and donkeys. Below the statue are separate troughs for horses and dogs. (© Historic England Archive)

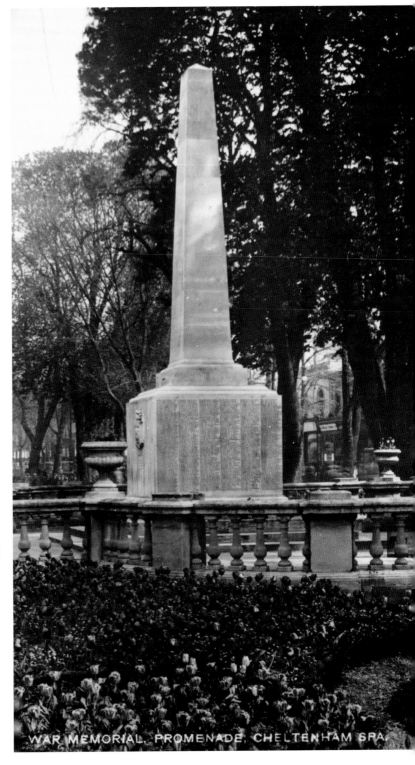

The War Memorial, *c.* 1925
Unveiled on 1 October 1921 to commemorate the people who lost their lives in the First World War, the memorial has recently undergone major restoration work as part of the war's centenary. In total, 761 Cheltonians died, forty-four of whom perished on 25 September 1915, during the first day of the Battle of Loos. (Historic England Archive)

WAR MEMORIAL, PROMENADE, CHELTENHAM SPA.

Education

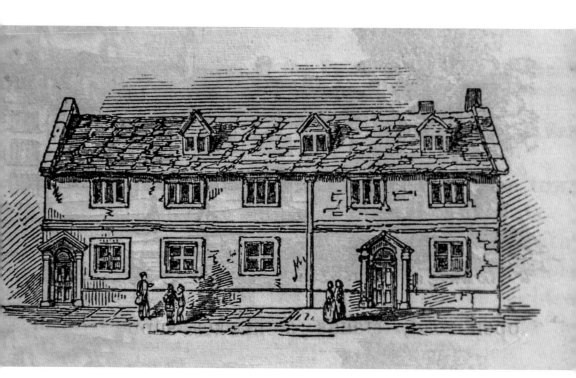

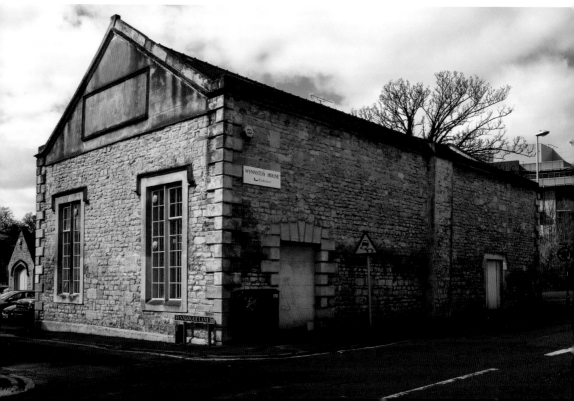

Above: Playground, Saint Gregory's Catholic School
Taken in 1971, this photograph shows the view looking towards Ivanhoe, a late Georgian house built *c.* 1826–32 on St James's Square. Founded in 1827, the Catholic School of Saint Gregory the Great has been located on its present site since 1936. Today, it serves a diverse social community of approximately 400 pupils. (© Historic England Archive)

Opposite above: Grammar School, High Street
Originally founded by the lawyer Richard Pate ('a very excellent and charitable man') in 1572 with a grant from Elizabeth I, Cheltenham's grammar school was rebuilt in 1887–89 before being relocated to its current site in Princess Elizabeth Way. This nineteenth-century print shows the original Tudor building with minor refurbishment that included pedimented doorcase entrances.

Opposite below: Wynnstay House
Now converted into offices, Wynnstay House originally opened in 1830 as a single schoolroom (measuring 60 x 30 feet) to accommodate 250 children aged between two and seven. Today, it is the country's oldest surviving building designed as an infant school. Originally commissioned by Francis Close, the school was inspired by the pioneering work of the educationalist Samuel Wilderspin.

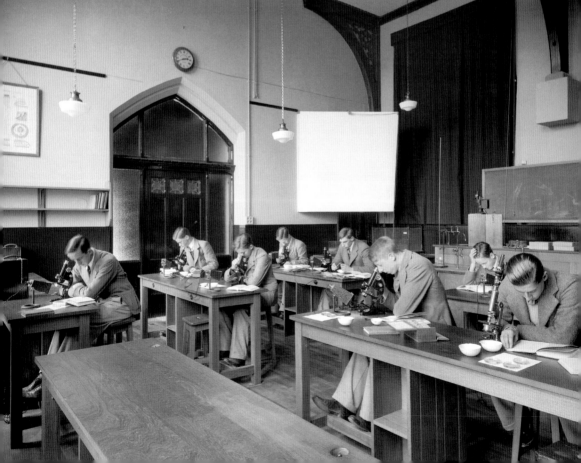

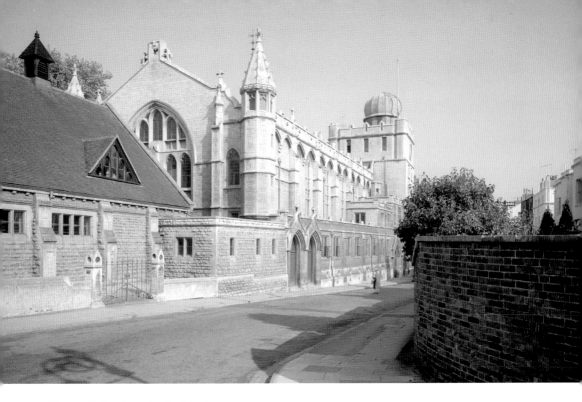

Above: Cheltenham Ladies' College
The first girls' school to be founded on the proprietary system, the college was established in 1854 at Cambray House. In 1873, it transferred to its current purpose-built accommodation in Bayshill. Much of the buildings were designed in an ecclesiastical Gothic style by John Middleton. This created a striking contrast to the neighbouring terraces built in a neoclassical style. (Historic England Archive)

Opposite above and below: Cheltenham College
Cheltenham College was established in 1841, initially occupying three houses in Bayshill Terrace near the town centre. Two years later it moved to its present site on Bath Road (see photograph opposite above). The college was founded primarily to support progression to university and military or civil service careers in the East India Company. Boys followed either a Classical route, with emphasis on the classics, mathematics, history, and Hebrew, or a Modern curriculum (also known as Military or Civil), which comprised subjects such as French, German, drawing, science, Sanskrit and Hindustani. The pre-Second World War photograph opposite below shows students engaged in scientific study. (Historic England Archive)

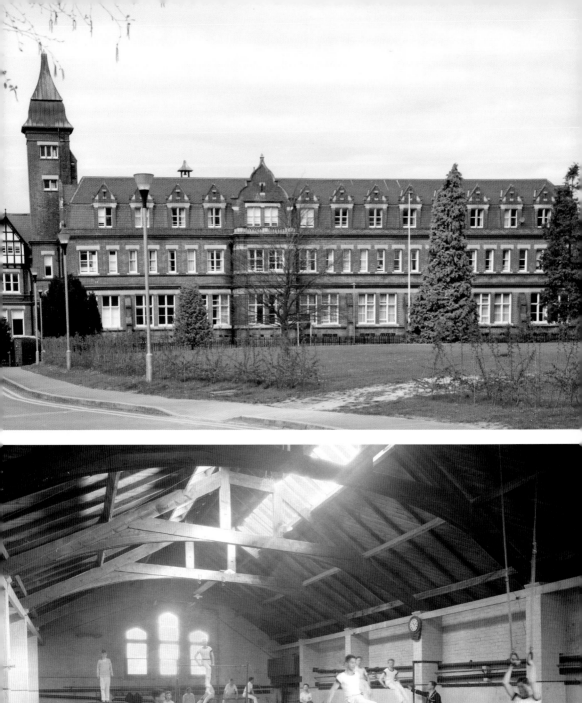
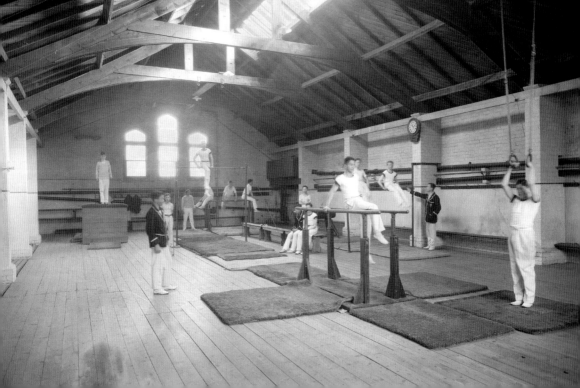

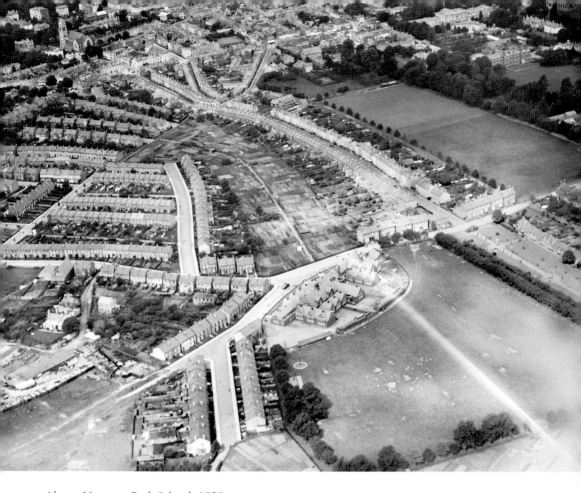

Above: Naunton Park School, 1928

Opened in 1906, the school was initially run as three separate schools for infant, junior and secondary pupils. During the First World War the buildings were used as a British Red Cross hospital. By 1918, 2,751 patients were admitted, the wounded soldiers benefitting from exclusive access to the neighbouring recreation ground at certain times. (© Historic England Archive. Aerofilms Collection)

Opposite above and below: Dean Close School

Dean Close School was opened in 1866 as a memorial to Francis Close, Cheltenham's well-known evangelical preacher who served as perpetual curate of St Mary's Church (now Cheltenham Minster) for thirty years from 1826 to 1856 and subsequently became Dean of Carlisle. The photograph above shows the main building from Shelburne Road, while the photograph below, dating from the 1930s, shows students using equipment in the gymnasium. Even in its earliest days a broad curriculum was taught, including subjects as diverse as scripture, book-keeping, mathematics, geography, history, French, German, Latin, Greek, natural science, drawing, music, and callisthenics. (Historic England Archive)

Entertainment and Leisure

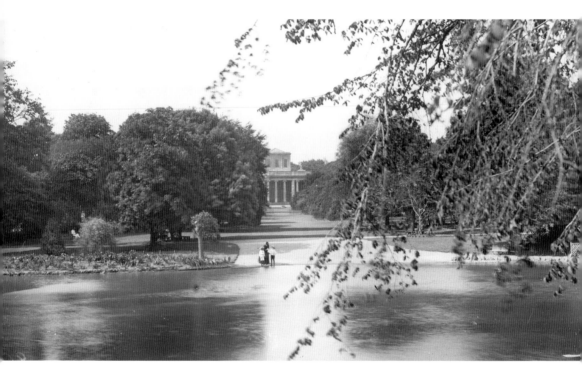

Pittville Lake
Originally formed in 1825–27 as part of the ornamental grounds of the (private) Pittville Estate, the 1-hectare lake formed an important attraction. One early visitor enthused, 'What a perfect scene of faërie-land broke upon our view as we stood upon the margin of the Pittville Lake, formed by the waters of the Swilgate, which … flows like molten silver hence to Tewkesbury.' (Historic England Archive)

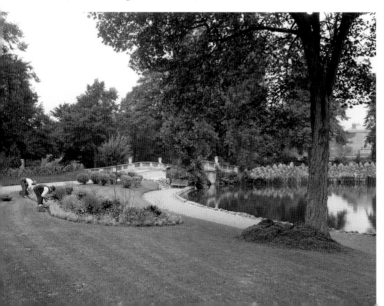

Gardens, Pittville Park
Originally comprising 8 hectares in front of the Pittville Pump Room, the gardens were laid out by the nurseryman Richard Ware in 1827. Designed to provide walks for spa visitors and estate residents, the gardens were not made accessible to the public until after the estate was acquired by the borough council in 1889. (Historic England Archive)

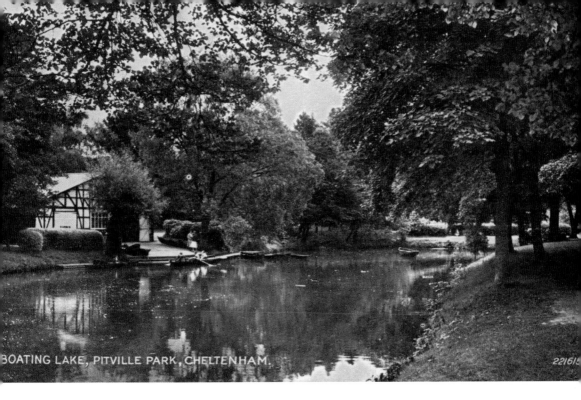

BOATING LAKE, PITVILLE PARK, CHELTENHAM.

221615

Boating Lake, Pittville Park
Located on the west side of the present-day park, which did not form part of the original Pittville Estate, the Boating (or Lower) Lake was opened as part of public pleasure grounds in 1894. The boathouse was designed by Joseph Hall, the borough surveyor, and initially hired out ten boats. (Historic England Archive)

Bandstand, Pittville Park
Built in 1900, the construction of a proper bandstand was welcomed by local residents to replace 'intrinsic makeshifts of drainpipes and planks' used previously for hosting concerts in the park. Originally sited directly in front of the pump room, a year later the bandstand was moved a short distance to its current position on the western side. (© Historic England Archive)

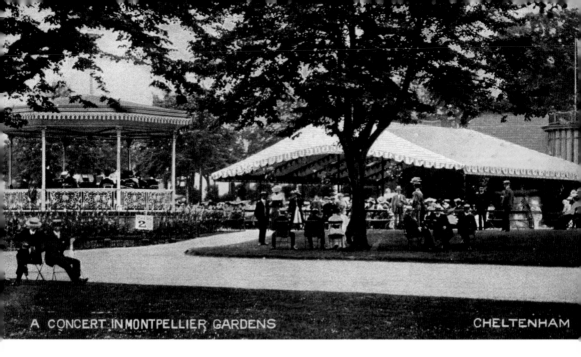

A CONCERT IN MONTPELLIER GARDENS CHELTENHAM

Above: Concert, Montpellier Gardens
Originally laid out in 1831, Montpellier Gardens were conceived as exclusive pleasure grounds for visitors to Montpellier Spa but were acquired by Cheltenham Borough Council in 1893. In 1900 an open-air stage (with awning) called the Proscenium was built close to the bandstand (see right in picture). The Proscenium was used until 1937 and has recently been restored as a public art gallery. (Historic England Archive)

Below: Montpellier Gardens
The gardens have hosted several important events in the town's history. These include balloon ascents, the founding of the local archery club in 1857 by Horace Ford, who is regarded as the 'father of modern archery', and the first successful parachute descent made by an Englishman (John Hampton) on 3 October 1838. (Historic England Archive)

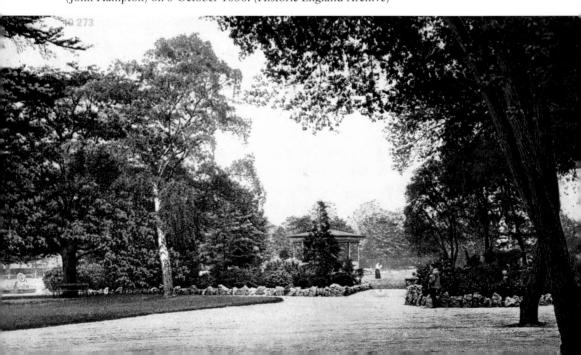

Montpellier Bandstand
Built in 1864 to a design by the Ironbridge-based Coalbrookdale Co., Cheltenham's Montpellier Bandstand has the distinction of being the oldest in the country still in regular use, having been rescued from dereliction and restored by Cheltenham Civic Society in 1994. Its attractive features include panels of ornamental ironwork incorporating a design of ladies' heads. (© Historic England Archive)

Cheltenham Croquet Club
Founded in 1869 in the town's Montpellier district, the club is one of the oldest and most influential in the country. Some of its members even developed the game's rules, tactics and format. Now located since 1920 adjacent to the East Gloucestershire Club, the club has hosted world championships in 2005 and British ones for most years since 1972.

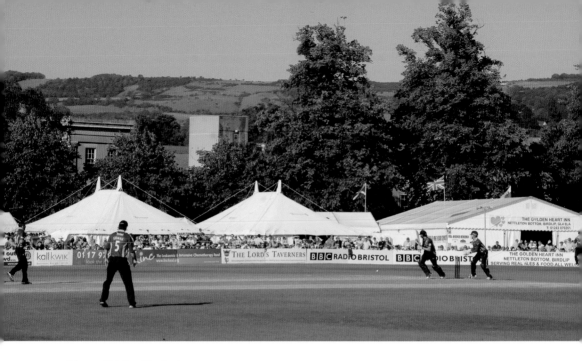

Above: Cricket Festival
Originally established by James Lillywhite in 1872, Cheltenham's Cricket Festival is the world's longest-running cricket festival. It has taken place on the same grounds of Cheltenham College for over 140 years, with recent attendances totalling more than 25,000 spectators. Famous cricketers who have played at the festival include W. G. Grace.

Below: Imperial Gardens
Originally developed as a commercial nursery and ornamental pleasure grounds for subscribers to the Sherborne or Imperial Spa, today the gardens are filled each year with approximately 25,000 bedding plants. These provide magnificent floral displays that are enjoyed by the many thousands of visitors who attend the outdoor events and festivals that take place here. (Historic England Archive)

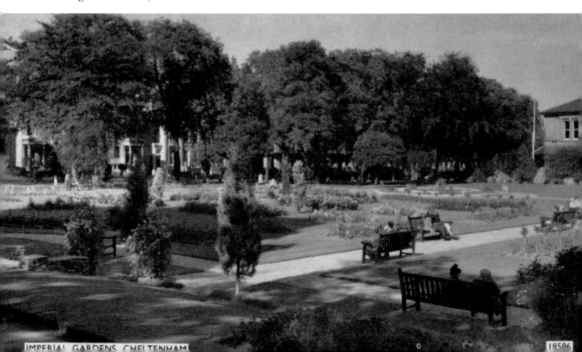

IMPERIAL GARDENS CHELTENHAM

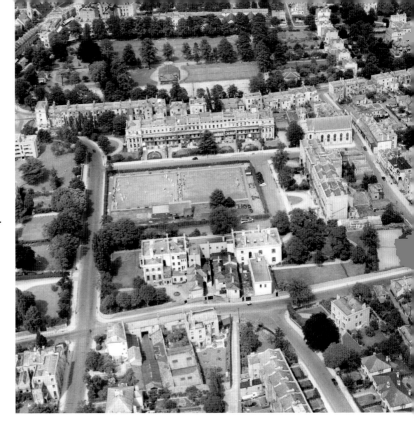

Ashburne Bowling Green, Suffolk Square
Founded in 1883, Cheltenham Bowling Club originally played matches in the Winter Gardens. However, in 1917 it transferred to Suffolk Square, after Lieutenant-Colonel F. J. Ashburner, after whom the green is named, donated land. In 1905, it became one of six founding members of Gloucestershire Bowling Association, and since 1914 has produced six international bowlers. (© Historic England Archive. Aerofilms Collection)

Naunton Park
Officially opened in 1893, Naunton Park provided a recreation ground and ornamental garden for the local community near Cheltenham College and beyond. In 1899, it included twelve alms cottages for the poor (still in use) – see right in picture. Originally, the garden was planted with agapanthus, agaves in large terracotta pots, trailing plants in urns and rose arches. (Historic England Archive)

UNTON PARK. CHELTENAM.

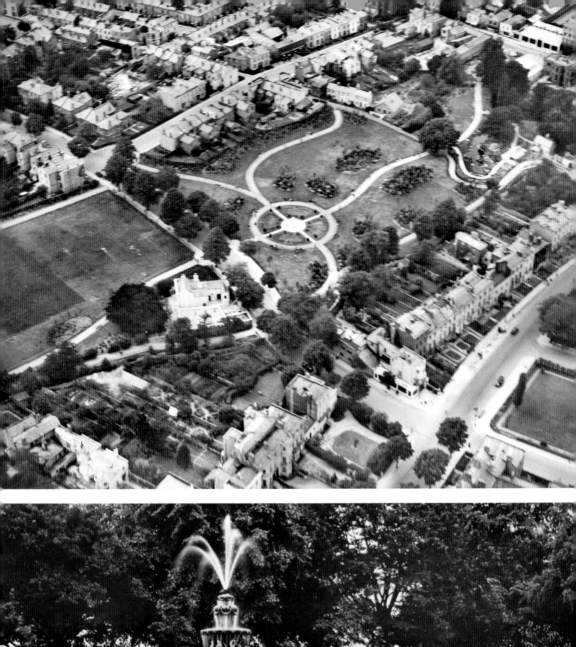
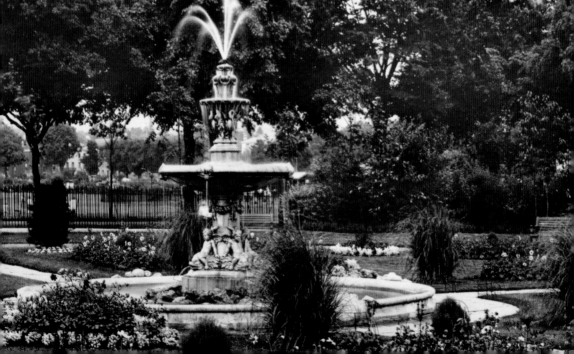

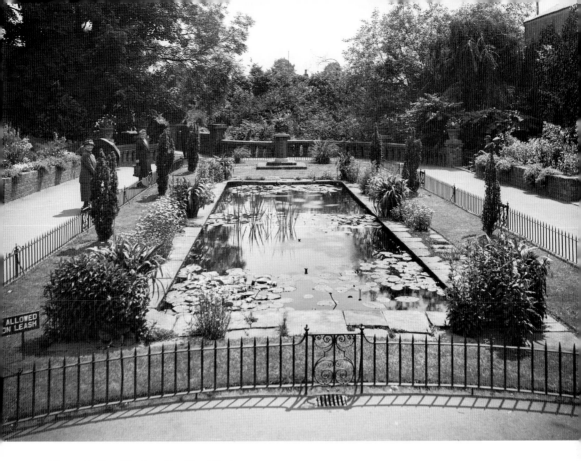

Above: Italian Garden, Sandford Park
Designed by the accomplished landscape artist Edward White, the water garden was opened
in 1927. Its aim was to provide 'a place where the people of Cheltenham could come to enjoy
nature in a peaceful environment'. Bricks and tiles from the Stonehouse Brick and Tile Co.
were used in its construction. (Historic England Archive)

Opposite above: Sandford Park, 1928
Taken the year after its inauguration as a park, this photograph shows part of the design,
masterminded by Edward White, which uses meandering paths to link its different sections.
The name Sandford is derived from the 'sandy ford', where many centuries earlier the highway
crossed. (© Historic England Archive. Aerofilms Collection)

Opposite below: Unwin Fountain, Sandford Park
Located close to the College Road entrance is the fountain built as a memorial to Herbert Unwin,
the second owner of Arle Court (today known as the Manor by the Lake). A businessman
who achieved success in the brewing, coal mining and newspaper industries, Unwin was also
remembered for being a philanthropist. (Historic England Archive)

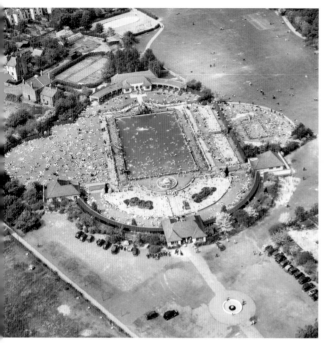

Left and below: Sandford Park Lido
Built in 1935 and still functioning as one of the oldest and largest outdoor heated swimming pools in the country, the lido quickly became a popular place where Cheltonians could relax in an informal environment. Still central to the lido's philosophy today are the concepts of public health and inclusion for all, particularly functioning as a shared space where men, women and children in all sectors of society can come together 'to see and be seen'. These two photographs illustrate the lido's considerable popularity: from 1947, when the black and white photograph was taken, to the present day where annual attendance levels on average reach more than 210,000.
(© Historic England Archive. Aerofilms Collection; © Historic England Archive)

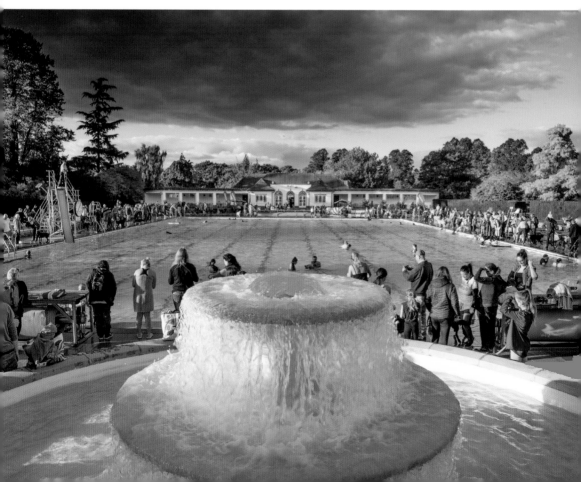

The Races

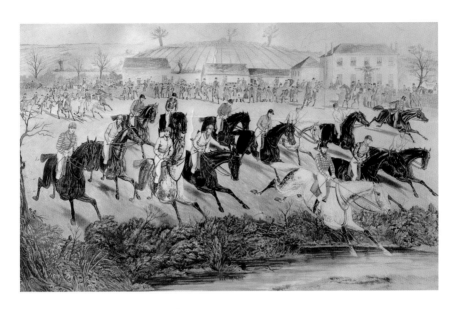

Above and below: The Early Days of Horse Racing

It is thought that the first Cheltenham races were held in 1815 on Nottingham Hill, close to Cleeve Hill, where, three years later, more formal races were staged. In 1819, the races on Cleeve Common, using a 3-mile-long course, were developed into a three-day event with spectators accommodated in a large grandstand that was visible from the Promenade. These two colour prints, produced after the artist Charles Hunt and published by I. W. Laird in 1841, are from a series of prints entitled 'Cheltenham Annual Grand Steeple Chase'. Among the riders is 'Black Tom' Olliver, who lived in Prestbury and became a renowned rider, winning the Grand National in 1842, 1843 and 1853.

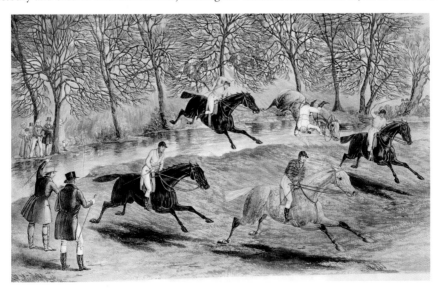

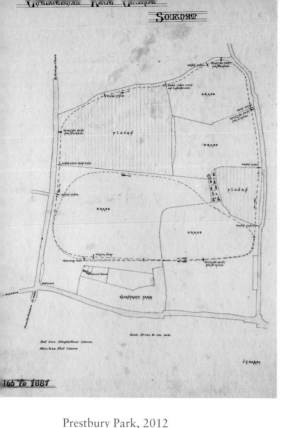

In Search of a Permanent Home

From 1823, while plans were conceived to transfer the races to Prestbury Park, this did not materialise until the end of the nineteenth century. In the intervening years, the races were held at various locations in the neighbourhood, or even discontinued for a short period. This map shows the 1866–87 course at Southam.

Prestbury Park, 2012

Dating from at least 1136, when it was a hunting park owned by John, Bishop of Hereford, its name was recorded as 'parc de Presteburye' in 1464. The first steeplechase was held in Prestbury Park in 1834 when it was owned by Lord Ellenborough. However, it was not until 1898 that it became the permanent home for Cheltenham's races.

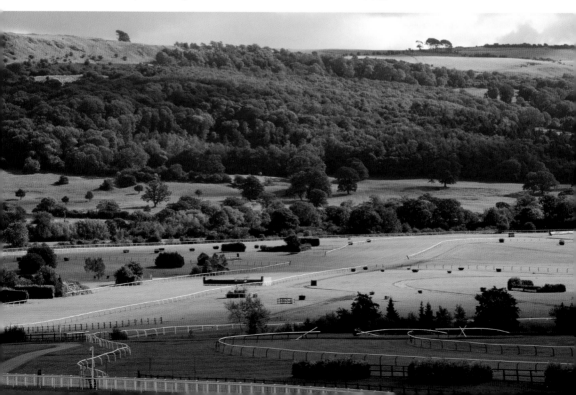

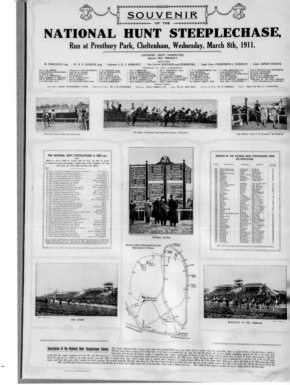

National Hunt Chase

Originally staged in 1860 in Market Harborough, the National Hunt Steeplechase was first run in Cheltenham in 1904 and 1905. At that time, the race migrated between different courses. In 1911, it became a permanent fixture at Prestbury Park where it is run on the 4-mile Old Course, requiring twenty-four fences to be jumped.

Cheltenham Racecourse Car Park, 1920

A century before this photograph was taken, average crowds of 30,000 racegoers visited the two-day annual race meeting, which included the Gold Cup. Today, the National Hunt Festival attracts 65,000 average attendances over the festival's four-day period, necessitating 36,500 vehicles to be parked, while 105,000 people arrive via the Cheltenham Spa railway station. (© Historic England Archive. Aerofilms Collection)

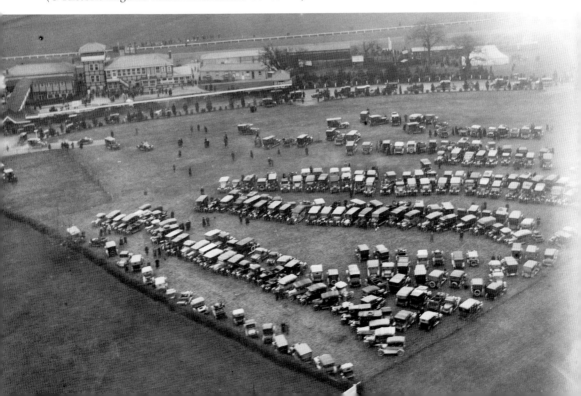

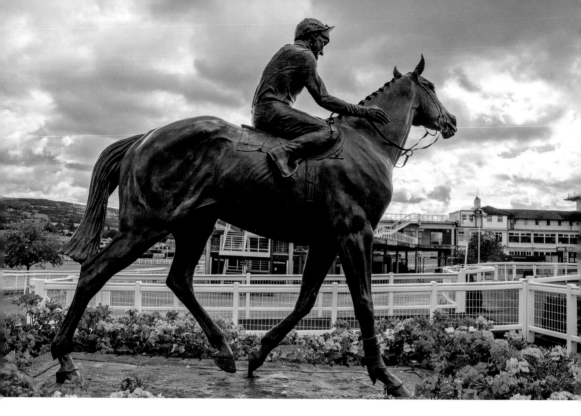

Above: Dawn Run Statue

Unveiled in 1987, this bronze sculpture by Jonathan Knight, which is located in the parade ring, shows Dawn Run ridden by Jonjo O'Neill. Considered by many to be the greatest mare in the history of National Hunt racing, Dawn Run is the only racehorse to have won both the Champion Hurdle and the Gold Cup, the latter in 1986.

Below: Istabraq Gate (detail)

Recently inducted into the Cheltenham Hall of Fame, Irish-owned Istabraq is regarded as one of the finest hurdlers of the modern day. Having won three consecutive Champion Hurdle crowns between 1998 and 2000, the thoroughbred was unable to compete for a fourth victory due to the festival being abandoned because of the outbreak of foot and mouth disease.

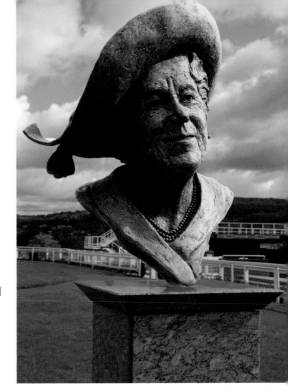

Commemorative Bust of the Queen Mother
Unveiled by HM the Queen in 2003, this bronze bust was sculpted by Angela Conner. A successful owner of National Hunt horses, in 1959 the Queen Mother established the National Hunt Two-Mile Champion Chase at Cheltenham. In 1980, to coincide with the Queen Mother's eightieth birthday, it was renamed the Queen Mother Champion Chase.

Best Mate Statue
Unveiled in 2006, this life-size racehorse statue sculpted by Philip Blacker celebrates Best Mate, who won three consecutive Gold Cups in 2002, 2003 and 2004. Considered one of the most loved horses in British horse-racing history, his sudden death from a suspected heart attack made national headlines. His ashes are buried near the winning post at Cheltenham.

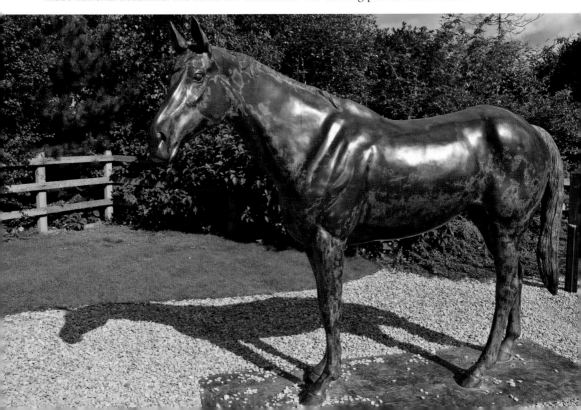

Above: The Winning Post
Today, the festival is estimated to generate an annual revenue of £100 million for Gloucestershire, with over £1 million offered in daily prize money and a total of approximately £2.3 million being taken in cash machines per day. The festival's longest race remains the National Hunt Chase, requiring 4 miles to be covered before reaching the finishing line.

Below: Winners' Enclosure
Before a winner can enter the Winners' Enclosure on Gold Cup day, it will need to have jumped twenty-two fences covering a distance of 3 miles and 2.5 furlongs. Today, the prize money for this single race amounts to £625,000. Currently, there are twenty-seven other races at the festival.

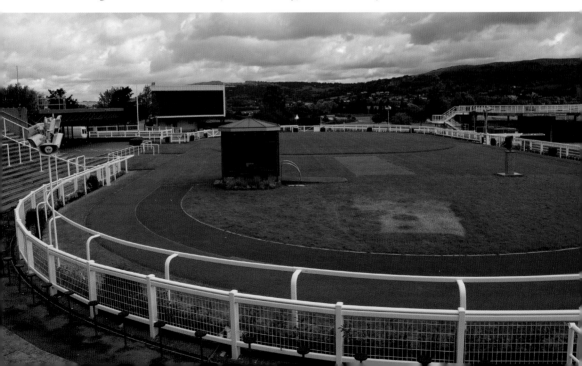

Industry and Commerce

Right and below: Whitbread Flowers Brewery, 1998

The recorded brewing of beer in Cheltenham dates back to at least the thirteenth century. From 1760, the most notable brewery was in Fleece Lane (now Henrietta Street), where a 35-foot-deep well afforded the daily supply of 27,000 gallons of water. On 1 October 1998 brewing ceased altogether in the town, although a number of small local independent breweries have recently begun operating. However, part of the brewery building, built in 1898, still stands today, forming the centrepiece of the leisure and retail complex known as the Brewery Quarter. The photographs show the copper brewing vat (see right) and a woodblock printing set (see below) that was once used in the brewery. (© Crown copyright. Historic England Archive)

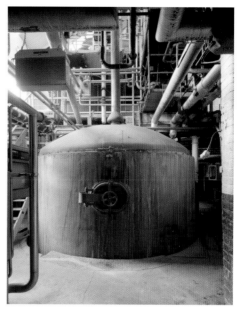

Railway Station

Cheltenham's sole remaining railway station, at Lansdown, was built in 1840 to serve the Birmingham and Gloucester (later Midland) Railway, which initially linked Cheltenham to Birmingham and Bristol. Another station at St James's Square operated between 1847 and 1966 to serve the Great Western Railway.

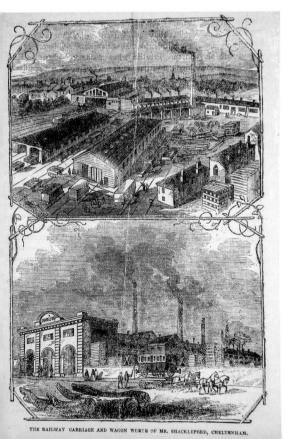

THE RAILWAY CARRIAGE AND WAGON WORKS OF MR. SHACKLEFORD, CHELTENHAM.

Shackleford's Railway and Carriage Works

Established by 1850 in Albion Street, Shackleford's Carriage Works produced railway carriages for the Great Western Railway. In 1857 it moved to a site near St James's station and, during the 1860s, following a partnership with a Swansea firm, became known as the Cheltenham & Swansea Wagon Co.

Devil's Chimney, 1892
Situated on the slopes of Leckhampton Hill, the rock formation known as the 'Devil's Chimney' was probably created by quarrymen early in the nineteenth century. Made from Lower Freestone, the structure withstood an earthquake in August 1926 which left some significant cracks. However, repairs carried out in 1985 have since then stabilised it. (Historic England Archive)

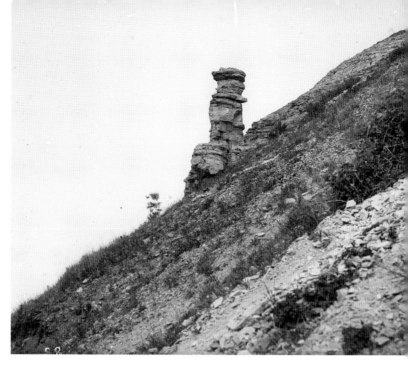

Strozzi Palace
Today recently converted into a hotel, in 1895 this terracotta brick building in St George's Place initially served as the principal substation to the town's electricity works at Arle. Modelled on the fifteenth-century Strozzi Palace in Florence, the building was later converted into offices for the Electricity Company.

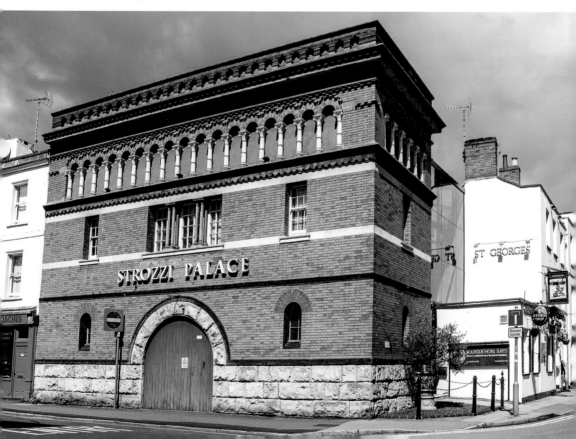

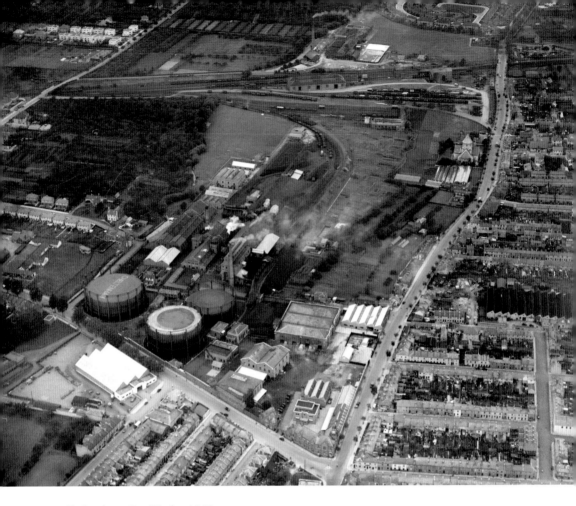

Cheltenham Gas Works, 1938
Gasworks existed on this Tewkesbury Road site from 1823 until its closure in 1969 with the loss of sixty jobs. In 1819, Cheltenham was one of the first places in the country to pass an act allowing the installation of gas lighting, which, reportedly, gave the town 'a new and captivating appearance … by night'. By 1852 it had 786 gaslights along its streets. (© Historic England Archive. Aerofilms Collection)

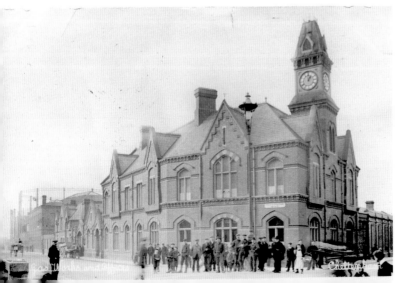

Gas Works Offices, 1906
Now known as Victoria House, the former gasworks offices reputedly date from 1855 to 1875. The building displays an extraordinary combination of Gothic Revival, French and baronial styles and includes an impressive clock tower, which, at first glance, could lead it to be mistaken for a town hall or public library.

Arle Court, 1947
Now known as the Manor by the Lake, Arle Court was built in 1854–58. While today it serves as a venue for weddings and other events, during the past 160 years the house and estate have functioned as a private residence, a film studio and, as shown here, the offices and industrial factories of George Dowty's aviation company. (© Historic England Archive. Aerofilms Collection)

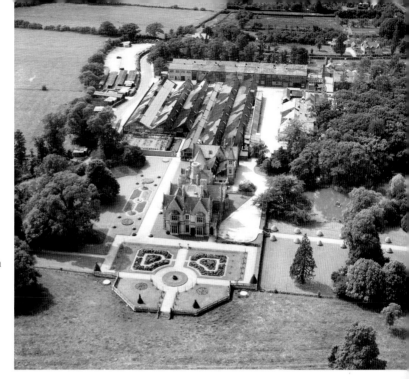

Whaddon Engineering Works, 1947
This factory, still located in Cromwell Road, was established by Walker, Crosweller and Co. Ltd, now Kohler Mira Ltd, in 1937. During the Second World War, the company produced a remarkable range of products to meet the armed forces' requirements for thermostatic and other types of mixing valves. In 1943 it employed 250 workers, mainly women. (© Historic England Archive. Aerofilms Collection)

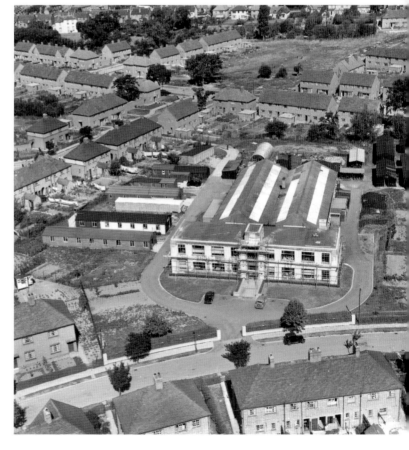

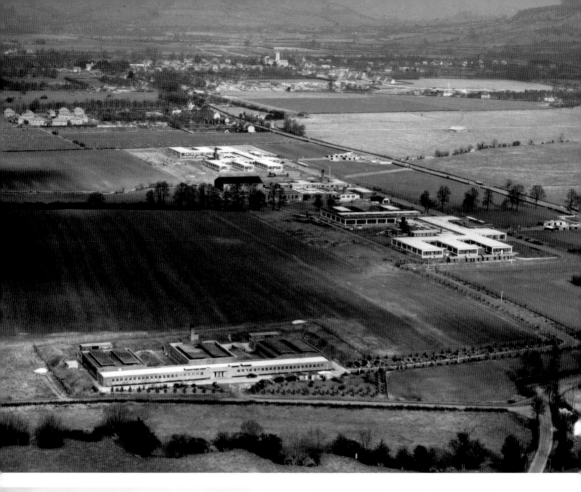

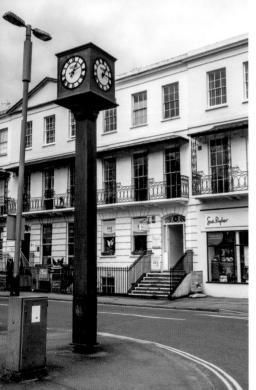

Above and left: S. Smith and Sons Ltd, 1949

In 1939, as part of the government's strategy to relocate aerospace industries away from potential air-raid locations, Samuel Smith established his engineering works on a 300-acre site at Kayte Farm in Bishop's Cleeve. During the Second World War the company manufactured ten million aircraft instruments and mechanisms, four million clocks and one and a quarter million speedometers and mileage counters. In 1956, the company donated the Town Clock (left), which is still situated next to the bus station in Royal Well Road. Today, the company is known as Smiths Aerospace and manufactures electrical and electronic components. (© Historic England Archive. Aerofilms Collection)

Bath and West Agricultural Show, 1947

In 1901, approximately 6.5 per cent of Cheltenham's working population was employed in agriculture. The photograph records the holding of the 'Bath and West' at Southam. During the show's 170-year history this was the first time that the four-day event was held in Cheltenham. It was hugely successful, with attendances totalling over 120,000. (© Historic England Archive. Aerofilms Collection)

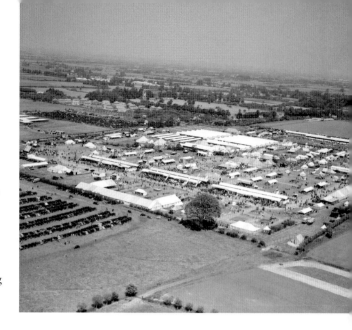

Sunningend Engineering Works, 1928

Located off Gloucester Road, where Lansdown Industrial Estate exists today, was the Sunningend works established in 1908 by H. H. Martyn and Co., the firm of architectural craftsmen. Here the company produced a diverse range of features in stone, wood and metal, including a new Speaker's chair for the House of Commons and fittings used on the *Titanic*. (© Historic England Archive. Aerofilms Collection)

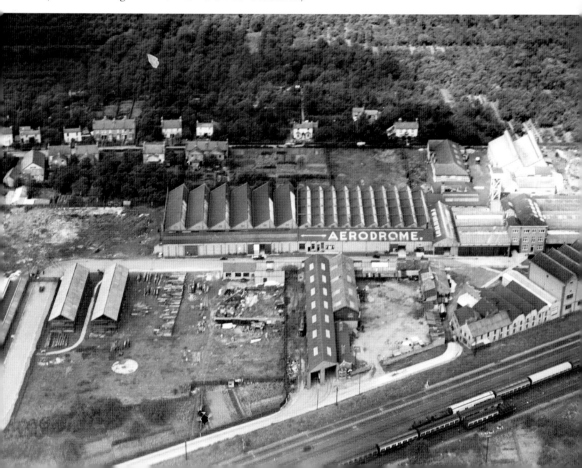

Leckhampton Hill Lime Production Project
This 1933 view from Leckhampton Hill shows the overbridge that once stood in Daisybank Road. Built by the Leckhampton Quarries Co. in 1924, the bridge formed part of an ill-fated scheme, begun in 1922, to produce lime on the hill and transport it to Charlton Kings by a specially built standard-gauge railway. (Historic England Archive)

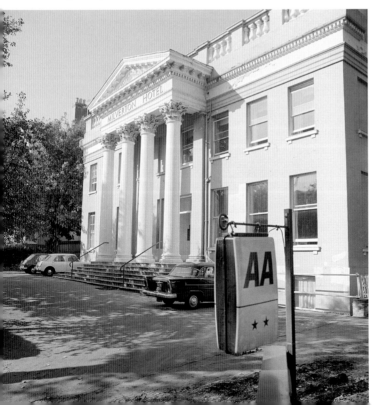

Milverton Hotel
Built *c.* 1839–50 in Bayshill Road as a detached villa with an imposing four-column Corinthian portico, the building was later converted into a hotel and then, during the 1980s, into offices for the Kraft company. As a hotel one of its famous residents was the world-famous aviator Captain Charles Douglas Barnard, who made record-breaking flights between the two wars. (© Historic England Archive)

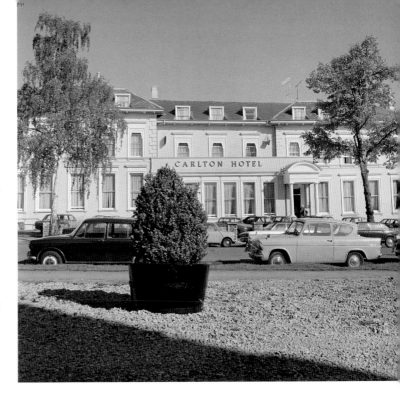

Carlton Hotel
Now known as the Hotel du Vin, this hotel located in Parabola Road was also previously known as the Moray House Hotel when Norman Wisdom, the entertainer, was billeted there as a member of the Royal Corps of Signals from 1943 to 1945. He claimed to have worked at a top-secret establishment known as 'CNW – Cheltenham Network'. (© Historic England Archive)

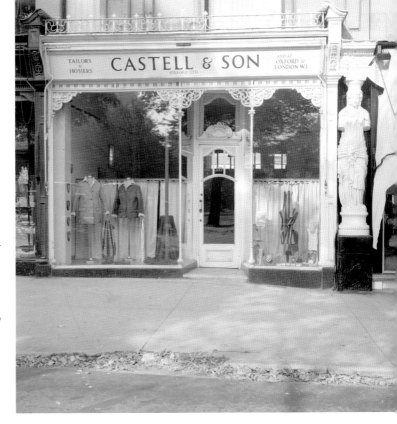

Shopping in Montpellier
This photograph of Castell & Son, the Oxford-based tailors and hosiers who opened a shop in Montpellier Walk, is a good example of how Montpellier developed into a specialist shopping area. Now part of the Shepherd and Woodward group, the company no longer trades in Cheltenham. (Historic England Archive)

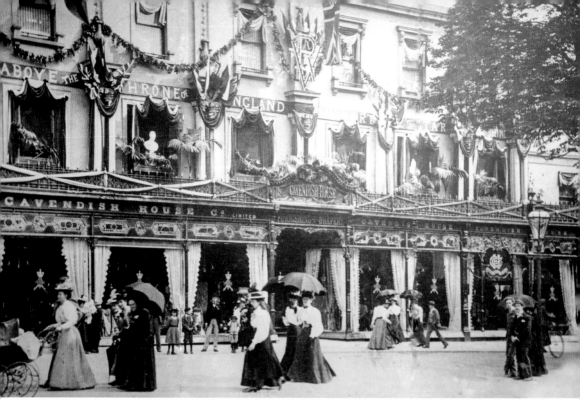

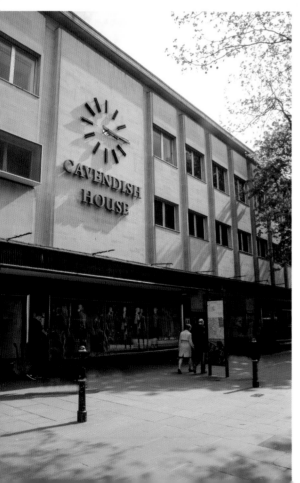

Above and left: Cavendish House
Now forming part of the House of Fraser group, Cavendish House first opened as a small shop on the Promenade in 1826 selling 'a choice selection of Silks, Muslins, Shawls, Handkerchiefs, Gauzes, Ribands, Gloves, Lace, Hose and Fancy Articles of English and Foreign Manufacture'. It was the first shop to be established on the Promenade and led the way for the rapid transformation of Cheltenham's most famous thoroughfare from a residential to a commercial street. Although the business initially traded under the name Clark and Debenham, it was unofficially known from its early days as 'Cavendish House'. The name was officially adopted in 1883. The photographs illustrate the contrast between its Victorian façade and its present-day modern frontage.

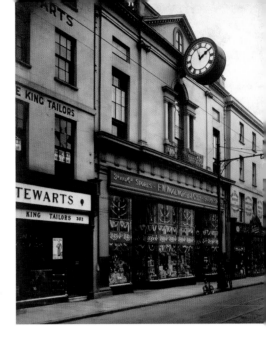

F. W. Woolworth and Co. Ltd
This 1920s photograph shows the town's Market House building in the Lower High Street when it was used as a Woolworth's store. Originally opened in 1809, the Market House became Cheltenham's Public Office by the 1840s, from where the town was administered, before it became a borough. (Historic England Archive)

'Boots' Corner', 1920
This view shows the junction of High Street with Clarence and North streets. Two large shops are visible: the department store E. L. Ward (previously occupied by The Empress Tea Stores Ltd, and today by Primark) and Boots the Chemist (top right). In 1927 Boots rebuilt their existing premises, which included a subscription library and art gallery. (© Historic England Archive. Aerofilms Collection)

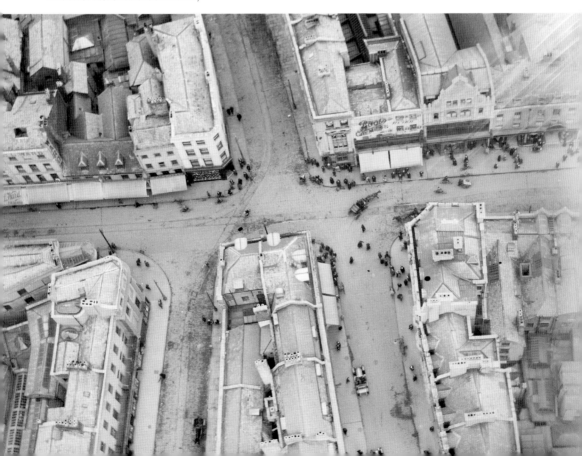

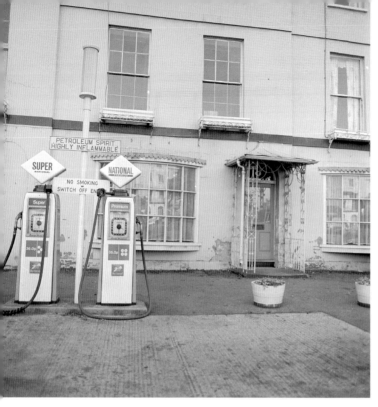

Grove Garage, 1971
This shows the National petrol pumps outside Grove Garage at Belle Vue Place. Currently part of Stirling House, the building was constructed *c*. 1810–20 as a private residence before becoming the workshops of the craftsman H. H. Martyn in 1888 when it was called Sunningend. By 1932 the building had become a showroom for Humber and, later, Rolls-Royce cars.
(© Historic England Archive)

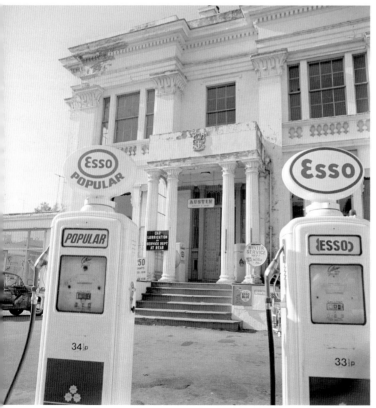

Lauriston House
Located in Montpellier Street, this impressive villa dates from 1839–40. Famous as the place where Dr Thomas Richardson Colledge, the founder of the Medical Missionary Society, lived towards the end of his life, the house was also used, for a short time, as a garage accommodating the premises of Austin Service and Sales.
(© Historic England Archive)

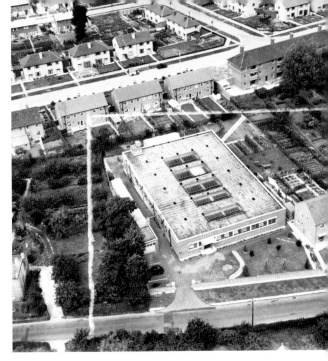

Montal Watch Fittings Ltd
This 1951 photograph shows the Priors
Lane factory, which once produced
watch cases and metal watch straps.
Originally founded in Birmingham
in 1942, the company moved to
Cheltenham after the Blitz. In July
1950 it was an exhibitor at the three-
day 'Made in Cheltenham' exhibition,
which was visited by 30,000 people.
In 2010, the company ceased trading.
(© Historic England Archive. Aerofilms
Collection)

Eagle Tower
The most conspicuous and controversial
of all Cheltenham's buildings is the
161-foot, thirteen-storey-high Eagle
Tower building, which originally
served as the administrative head office
and computer centre for Eagle Star
Insurance. Opened in 1968 at a cost
of £1.7 million as part of the office
decentralisation policy of the mid-
1960s, it has dominated the town's
skyline ever since.

Antique Shops
Occupied in the 1970s by Mr Embrey, a clock mender, this shop was located in Montpellier Street. Another example of Cheltenham's association with specialist antique dealers was Frank Drake who ran The Little Antique Shop at No. 1a Regent Street during the 1920s after previously trading from Leadenhall Street, London. Arthur Negus, the well-known antiques expert, was also once a resident of the town. (© Historic England Archive)

Ronald Summerfield's Antique Shop
A lifelong antiques collector, Ronald Summerfield ran his shop in Montpellier Avenue from 1952 until his death in 1989. When he died it took ten men four months to catalogue around two million items in his collections. Following their sale, the collections raised approximately £7 million for a charitable trust to support good causes throughout Gloucestershire. (© Historic England Archive)

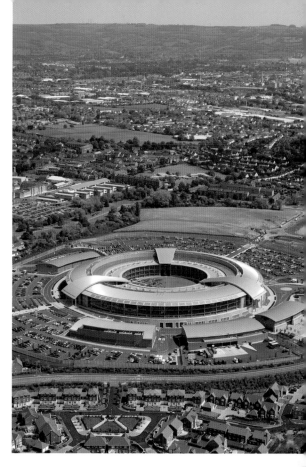

GCHQ

Since the early 1950s the Government
Communications Headquarters (GCHQ)
has been one of the area's largest employers.
Initially it occupied two sites, at Benhall
Farm and Oakley, sites used by the US
Army during the war. However, in 2003 its
new main building, known as the Doughnut
(above right), was completed, receiving
many accolades for its innovative design.
As one of the three UK Intelligence and
Security Agencies, along with MI5 and the
Secret Intelligence Service (MI6), GCHQ's
success depends on creating innovative
solutions to challenging problems. In view
of this, a circular design incorporating two
concentric rings of open-plan offices with a
wide 'street' (below right) running between
them was conceived to facilitate effective
knowledge sharing.

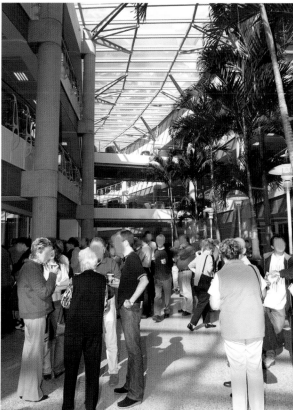

High Street Development

Today under development as a John Lewis store, originally this was the site of a set of almshouses founded by Richard Pate in 1574. By the nineteenth century it was occupied by the Vittoria Hotel and neighbouring Royal Hotel, the latter being converted from a house built for John de la Bere, the town's chief magistrate. More recently, it was the Beechwood Arcade shopping centre.

Acknowledgements

I am most grateful to Alan Murphy at Amberley Publishing for commissioning the book. Also, a number of museums, libraries and archive services have provided me with excellent support. My thanks in particular go to all the staff at Cheltenham Local Studies Centre. I am also grateful to Dr Steve Blake, Dr James Hodsdon, Neela Mann, Eric Miller and Jill Waller for commenting on the draft. I should also like to thank the following for granting me copyright permission to use various images: Cheltenham Local Studies Centre for permission to reproduce the historic photographs, prints and drawings on pp. 10 (below), 11, 34 (above), 37, 48 (below), and 80 (below); GCHQ Press Office for the two Crown Copyright images on p. 93; Dr David Wilson and Cheltenham Art Gallery and Museum for permission to reproduce the two photographs on p. 46; Sue Ryder Leckhampton Court Hospice for the image on p. 8 (below); Edward Gillespie for permission to reproduce the historic photographs, prints and drawings on pp. 73, 74 (above) and 75 (above); Sue Rowbotham for the image on p. 51 (below); Neela Mann for the image on p. 82 (below); Cotswold Archaeology for permission to reproduce the photograph on p. 10 (above); and the Manager, House of Fraser (Cheltenham) for permission to reproduce the historic photograph on p. 88 (above). I am also grateful to the Holst Birthplace Museum for permission to photograph Holst's Music Room (p. 44), and to Dr Simon Draper, Martin Watts, and David Magee for assistance with obtaining other permissions. The copyright of images on pp. 13 (above), 25 (above), 33, 38, 44, 45 (below), 47, 48 (above), 49, 50 (below), 51, (above), 52 (below), 55 (below), 56 (above), 58 (below), 62 (above), 67 (below), 68 (above), 73, 74, 75 (above), 76, 77, 78, 80 (above), 81 (below), 84 (below), 88, 91 (below), and 94 belong to the author. Finally, my heartfelt thanks go to my family, Meg, Rachel, and Catrin, for their patience, support and encouragement.

About the Author

David Elder lives in Gloucestershire. He is the author of several books on Cheltenham, Gloucester, Tewkesbury and the Cotswolds. He also co-authored *Cheltenham in Antarctica*, a biography about Edward Wilson, the Antarctic explorer. You can find out more about David's writing from his website, davidelder.net.

About the Archive

Many of the images in this volume come from the Historic England Archive, which holds over 12 million photographs, drawings, plans and documents covering England's archaeology, architecture, social and local history.

The photographic collections include prints from the earliest days of photography to today's high-resolution digital images. Subjects range from Neolithic flint mines and medieval churches to art deco cinemas and 1980s shopping centres. The collection is a vivid record both of buildings that are still part of everyday life – places of work, leisure and worship – and those lost long ago, surviving only in fragile prints or glass-plate negatives.

Six million aerial photographs offer a unique and fascinating view of the transformation of England's towns, cities, coast and countryside from 1919 onwards. Highlights include the pioneering photography of Aerofilms, and the comprehensive survey of England captured by the RAF after the Second World War.

Plans, drawings and reports provide further context and reconstruction artworks bring archaeological sites and historic buildings to life.

The collections are housed in a purpose-built environmentally controlled store in Swindon, which provides the best conditions to preserve archive items for future generations to enjoy. You can search our catalogue online, see and buy copies of our images, as well as visiting our public search room by appointment.

Find out more about us at HistoricEngland.org.uk/Photos
email: archive@historicengland.org.uk
tel.: 01793 414600

The Historic England offices and archive store in Swindon from the air, 2007.